DATE	ISSUED TO

ANOUCK DURAND
ETERNAL FRIENDSHIP

TRANSLATED BY ELIZABETH ZUBA

INTRODUCTION BY ELIOT WEINBERGER

siglio NEW YORK 2017

Thank you to the Albanian photographers and their families who agreed to share their pictures and stories. —Anouck Durand

Originally published as *Amitié Éternelle* © 2014, Éditions Xavier Barral. Published in English by arrangement with Éditions Xavier Barral, Paris.

Concept, text and design by Anouck Durand.

All archival images and texts used with permission of the copyright holders.

"A True Story" by Gilles de Rapper © 2014.
Introduction by Eliot Weinberger © 2017.
English translation by Elizabeth Zuba © 2017.

Cover and dust jacket design: Natalie Kraft.

This work received the French Voices Award for excellence in publication and translation. French Voices is a program created and funded by the French Embassy in the United States and FACE Foundation (French American Cultural Exchange).

FRENCH
VOICES

FIRST EDITION
ISBN: 978-1-938221-14-9
Printed and bound in South Korea

siglio uncommon books at the intersection of art & literature
PO BOX 111, Catskill, New York 12414 www.sigliopress.com

Available to the trade through D.A.P./Artbook.com
75 Broad Street, Suite 630, New York, NY 10004
Tel: 212-627-1999 Fax: 212-627-9484

INTRODUCTION

The Albanian language has a tense for surprise. That is, the verb-ending changes if one says "You speak Albanian" or "You speak Albanian!" The physical landscape of the country is punctuated with periods: 200,000 tiny dome-shaped concrete bunkers, scattered everywhere, meant to hold one or two snipers each, and built by Enver Hoxha in the delusion that it would repel an imagined Soviet invasion. But, even more, the psychic landscape is a forest of exclamation marks entangled with question marks: surprise and bewilderment.

Albanian did not have its own written language until the 20th century, and 95% of the women couldn't read it. Fishermen on the coast, farmers in the hills, shepherds in the mountains, the blood feuds of continually warring clans: Albania was always an agricultural colony or the backwater of an empire or occupied territory on the way to somewhere else for the Greeks, the Romans, the Byzantines, the Italo-Normans, the Serbs, the Venetians, the Bulgarians, the Ottomans, the Italian Fascists, the Nazis. In its first years after World War II, the new People's Republic of Albania under Hoxha—who was prime minister, defense minister, foreign minister, and the commander-in-chief of the army—became a client state of Tito's Yugoslavia. Breaking with Yugoslavia, it became a client state of Stalin's Soviet Union, copying the Stalinist economic system of state enterprise and collectivized farming and the Stalinist political system of mass imprisonments and executions. The penalization of "enemies of the people" extended to their grandchildren.

Breaking with the Soviet Union over the "treacherous revisionism" of Khrushchev's support for "different roads to socialism" and his denunciation of Stalin's iniquities, it renounced the Warsaw Pact of Eastern European nations and became a client state of Mao's China, copying the Maoist Cultural Revolution with its own Cultural and Ideological Revolution, abolishing all mosques and churches, sending bureaucrats to the factories and the fields, suppressing "foreign influences." Breaking with China after the treacherous revisionism that had allowed Nixon to visit Beijing, Albania became essentially alone in the world—through Hoxha's death after a forty-year reign, through the collapse of the Soviet Union and the Warsaw Pact nations—until its People's Republic itself collapsed in 1992. Factories and collective farms were

then abandoned, and capitalism brought its own treacheries, as most of the people lost most of their savings, caught up in the hysteria of a pyramid scheme. For years it survived on the money sent home by Albanians who, after the decades of strict national confinement, were now working abroad.

In the Communist countries, photographic documentation was an essential tool of propaganda, for Marxist-Leninism considered itself scientific, and the assumed objectivity of photography was inextricable from the social realism, however glorified, it promoted in the arts and the supposed realism, however implacable, it enacted in daily life. But these photos were not only an unreal realist kitsch of happy workers in the factories and bountiful harvests and valiant soldiers: Reality and therefore its documentation were subject to continual revision in the struggles against revisionism. New-found enemies had to be cut out of negatives, events forgotten, archives destroyed. (It is one of the ironies of this book that the photos of China by one of the photographers survived only because he was in prison at the time the orders were given to burn them.) An authoritarian state depends not only on force, but on the absolute control of information, the creation of its own reality. (Whether this is still possible in the internet era, when even the democracies are dazed by the near-total democratization of information and pseudo-information, remains to be seen.)

The New Society needed to reinvent every aspect of life, including things as seemingly neutral as the technology of photography. Thus, Albanian photographers were sent to China to learn the new Socialist tri-chrome printing method that would replace decadent capitalist Kodak film; they were given Chinese Red Flag cameras to dislodge dependency on their Western European models. Equally surprising, Albanian photo studios were shut down as a bourgeois indulgence, or used only for the inevitable purposes of identification documents. This is exactly opposite to the current taste for studio photographs from everywhere in the world, which sees them, within the strict genre of their poses, as unfiltered representations of the people, highborn and low, of a given culture. It is a People's Art, but its works are the aspirational images of individuals from the masses. In the People's Republic, there was only the masses, and the only permitted images of its people were those manipulated to serve the aspirations of the republic.

World history tends to remember the hegemonies of the great powers, though the world itself is a more complex net of unlikely correspondences, one where Bollywood movies and Brazilian *telenovelas* enter the dreams of far-flung villagers abroad, and one where—in this book—the Eternal Friendship of Albania and China oddly intersects

with the personal friendship of two photographers, a Muslim who hid a Jew during the war, and who never met again.

Small and largely ignored, Albania has a way of appearing in unexpected places. As the final state beacon of Stalinism, it still remains inspirational for the true believers of the Voltaic Revolutionary Communist Party in Burkina Faso or the Group of Popular Combatants in Ecuador or the Communist Party of Labor in the Dominican Republic or the Communist Party of Togo. The Australian writer Lloyd Jones wrote a novel about Enver Hoxha's official double, which, since it was about Albania, was assumed to be non-fiction. In the U.S., one African-American poet, Amiri Baraka, wrote essays in praise of Hoxha; another, Will Alexander, has a long poem on his death:

> the expiring Enver Hoxha
> prone
> like a skull on a slab of Marxist invectives
> with a glut of crushed worms slipping from his forehead
> [. . .]
> his dictatorial mutterings
> like a spurt of unseasonable frog gills
> like a grotesque insecticidal frenzy calling out
> from tormented histamine gardens

And the short-lived Eternal Friendship lingers on: A few years ago, on a boat trip around Hong Kong harbor during a poetry festival, the Chinese poets of a certain age serenaded the Albanian poet Luljeta Lleshanaku with stirring martial songs they still remembered from Albanian movies: During the Cultural Revolution, those were the only foreign films allowed to be shown. (Slightly earlier, in yet another unlikely correspondence, China mainly screened old Mexican movies, which were neither Soviet nor American, and cheap to rent. The Mexican film stars of the 1940s continue to have a nostalgic fandom on the mainland.) Albania officially erased most of the traces of the Eternal Friendship, but those traces remain not only in the neglected archives amazingly uncovered here, but in random memories. This book calls itself "semi-fictional," but perhaps it's best considered as one of those memories, partially reconstructed.

–Eliot Weinberger

PEKING, JUNE 1970

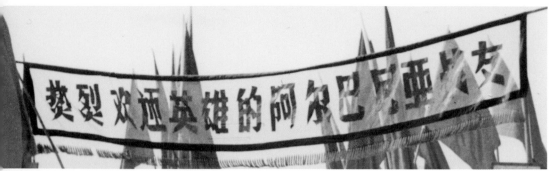

★*WELCOME COMRADES OF THE HEROIC ALBANIAN PEOPLE*

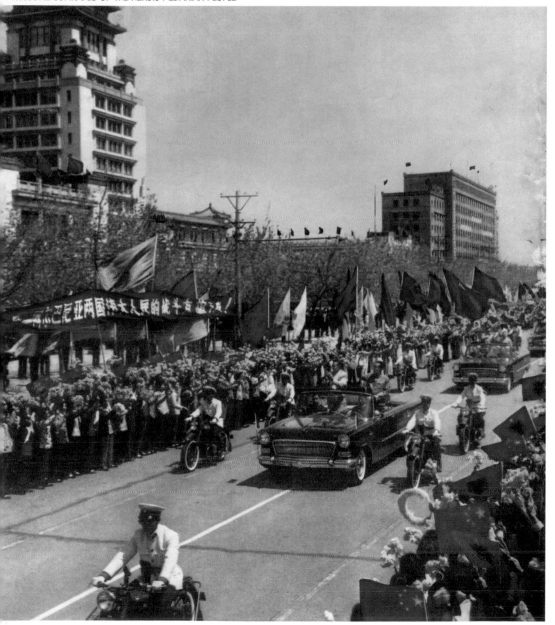

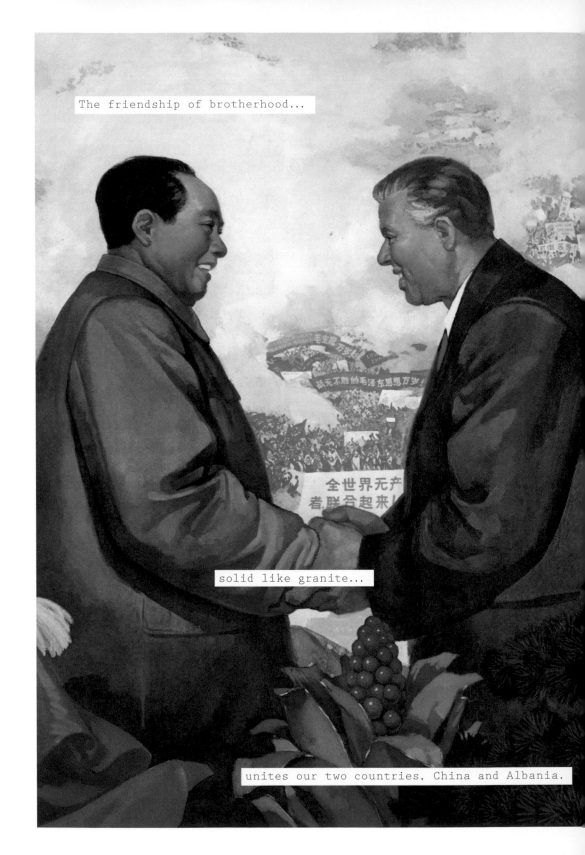

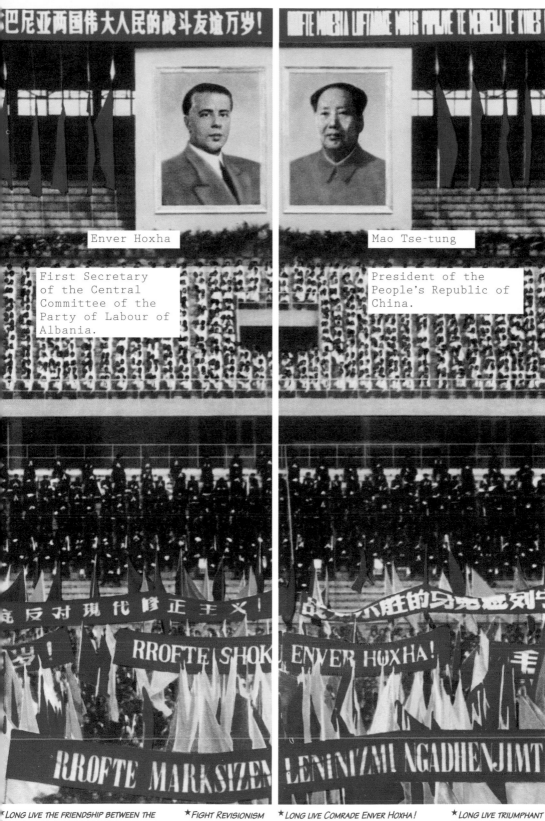

Enver Hoxha

First Secretary of the Central Committee of the Party of Labour of Albania.

Mao Tse-tung

President of the People's Republic of China.

★ LONG LIVE THE FRIENDSHIP BETWEEN THE CHINESE AND ALBANIAN PEOPLE

★ FIGHT REVISIONISM

★ LONG LIVE COMRADE ENVER HOXHA!

★ LONG LIVE TRIUMPHANT MARXISM-LENINISM

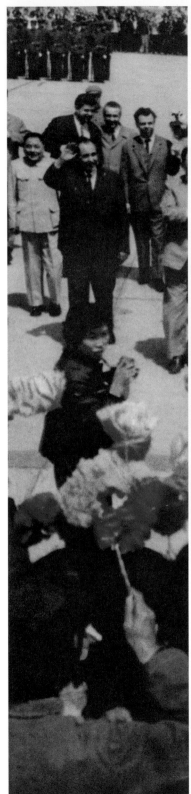

REFIK VESELI

PLEURAT SULO

It's strange being on this side of the camera.

We're usually the ones taking the pictures.

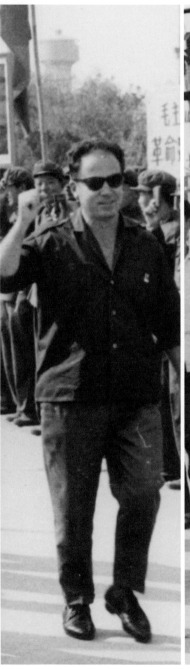

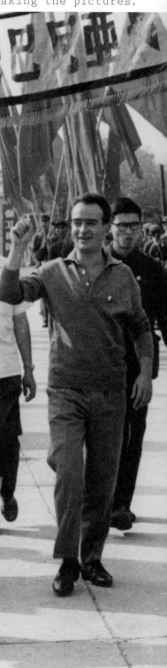

But the Chinese have decided to immortalize our visit.

It should be said that China has few friends these days.

And Albania, many enemies.

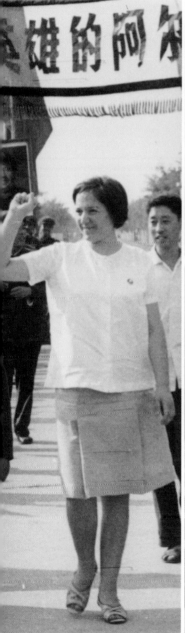

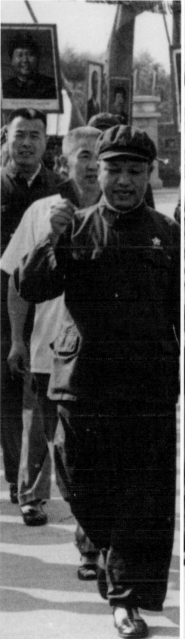

*WELCOME COMRADES OF THE HEROIC ALBANIAN PEOPLE!

*VICTORY TO THE REVOLUTIONARY PATH OF MAO TSE-TUNG'S PROLETARIAT

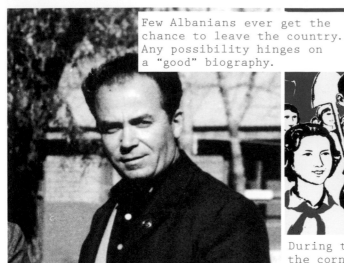

Few Albanians ever get the chance to leave the country. Any possibility hinges on a "good" biography.

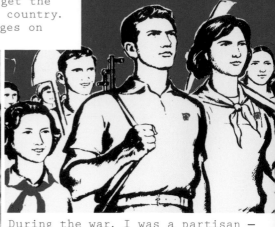

During the war, I was a partisan — the cornerstone of a "good" biography.

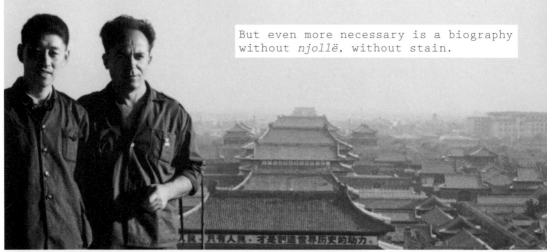

But even more necessary is a biography without *njollë*, without stain.

A stain is a dissenting cousin who has tried to flee the country.

Or a family member who opposed the communists during the war.

From now on, it is also an undesirable link to the Russian imperialists.

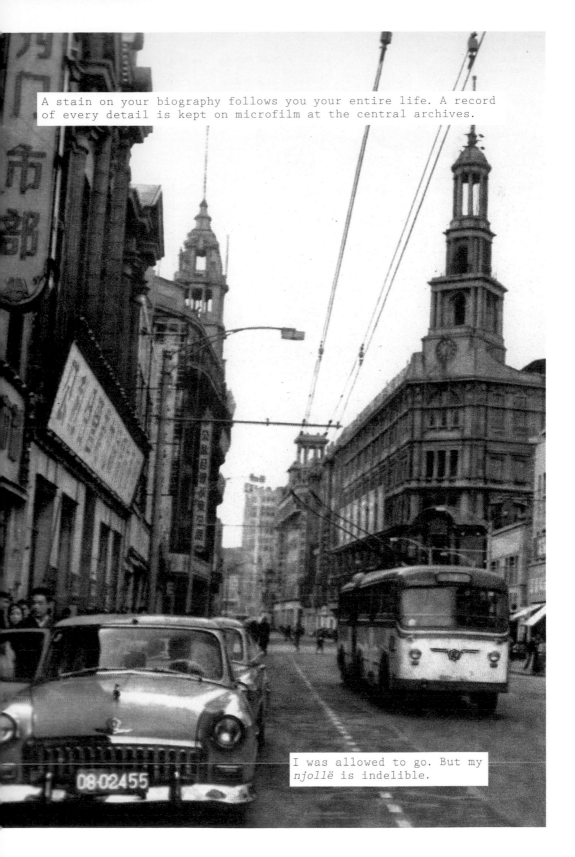

A stain on your biography follows you your entire life. A record of every detail is kept on microfilm at the central archives.

I was allowed to go. But my *njollë* is indelible.

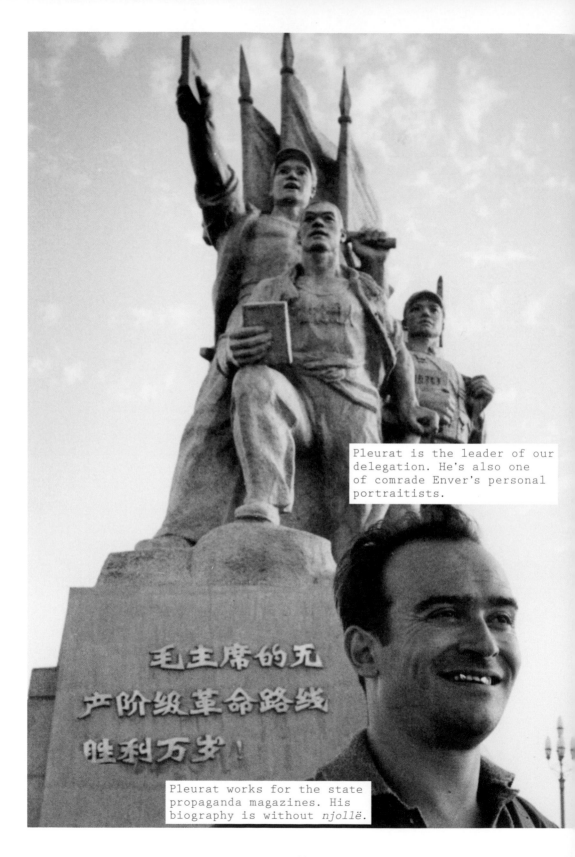

Pleurat is the leader of our delegation. He's also one of comrade Enver's personal portraitists.

毛主席的无
产阶级革命路线
胜利万岁!

Pleurat works for the state propaganda magazines. His biography is without *njollë*.

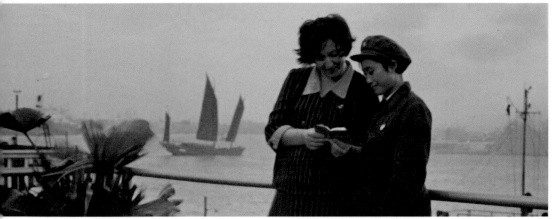

I don't know Katjusha as well. She's a technician, trained at the Albanian Telegraphic Agency. No one knows the exact nature of her work.

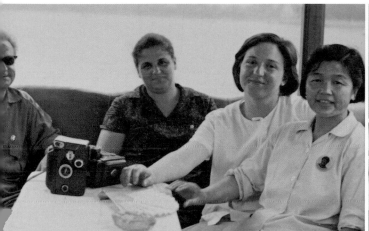

Some say it's a secret laboratory, at the direct disposal of comrade Enver and the highest leadership of the party.

I suppose that's why she's here.

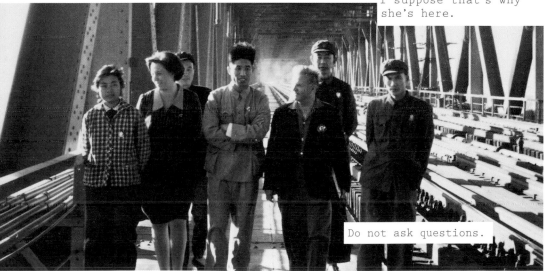

Do not ask questions.

★ LONG LIVE THE CHINESE COMMUNIST PARTY

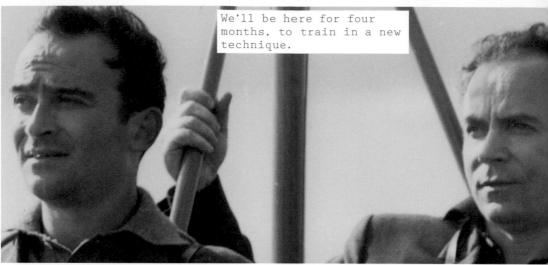

We'll be here for four months, to train in a new technique.

A complex colorization method, we're told, reserved for Mao.

But because Enver is as major a figure as Mao, the Party has decided that we should use the same technique for the portraits of the comrade First Secretary of the Central Committee of the Party of Labour of Albania.

Punimi i materialeve fotografike me ngjyra

MATERIAL I GRUMBULLUAR E I PUNUAR NGA

Ilo Vero Golloshi

METHOD FOR COLOR
PHOTOGRAPHY

(Sintezë sotrative)
z botese

(sintezë aditive)
mb ledbose.

The technique is a way of processing color photographs from black-and-white film. It's called tri-chrome printing.

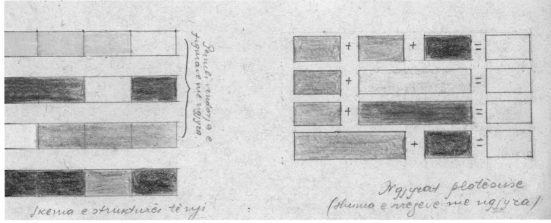

Skema e strukturës tëryi

Ngjyrat plotësuese
(shuma e ngjeve me ngjyra)

It consists of taking three shots of the same image through three different filters: yellow, blue, red.

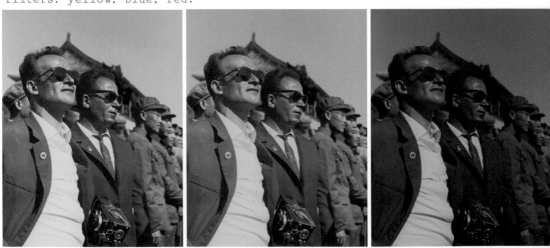

By the end, you have a color photo.

It takes time and infinite patience to superimpose the three negatives in perfect alignment.

The Chinese photographers have done us a great honor by sharing their method with us.

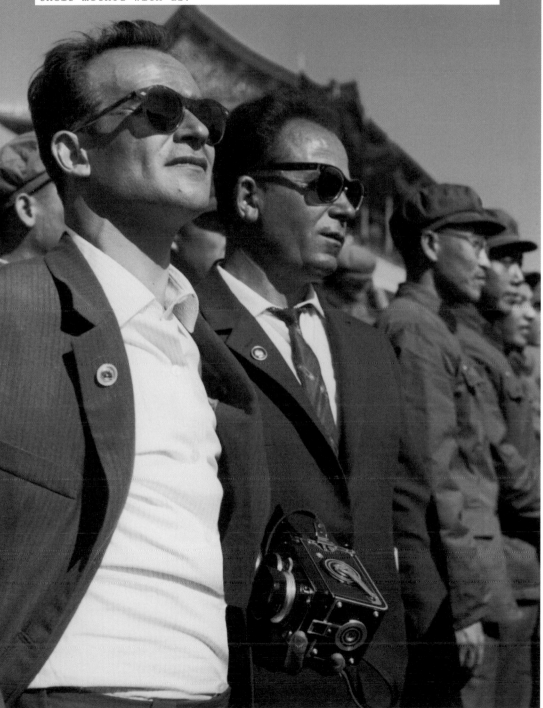

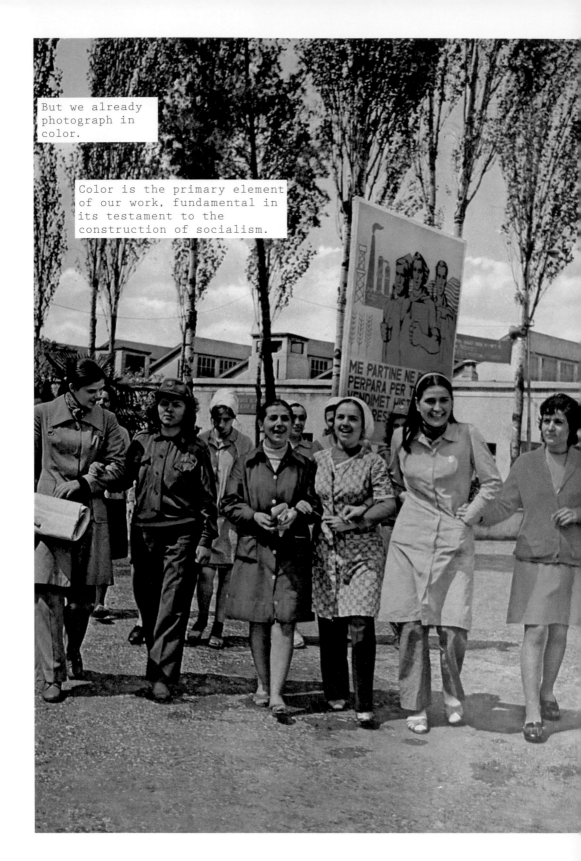

But we already photograph in color.

Color is the primary element of our work, fundamental in its testament to the construction of socialism.

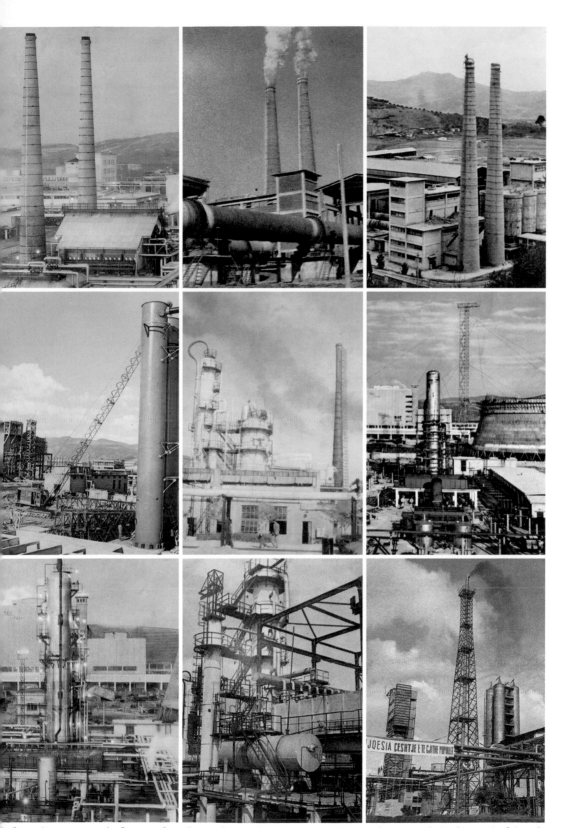

Color is essential to showing that the country is modern and industrialized.

fficially, capitalist equipment is forbidden. But we still use Kodak film.
nternational orders are made directly by the Party leadership.

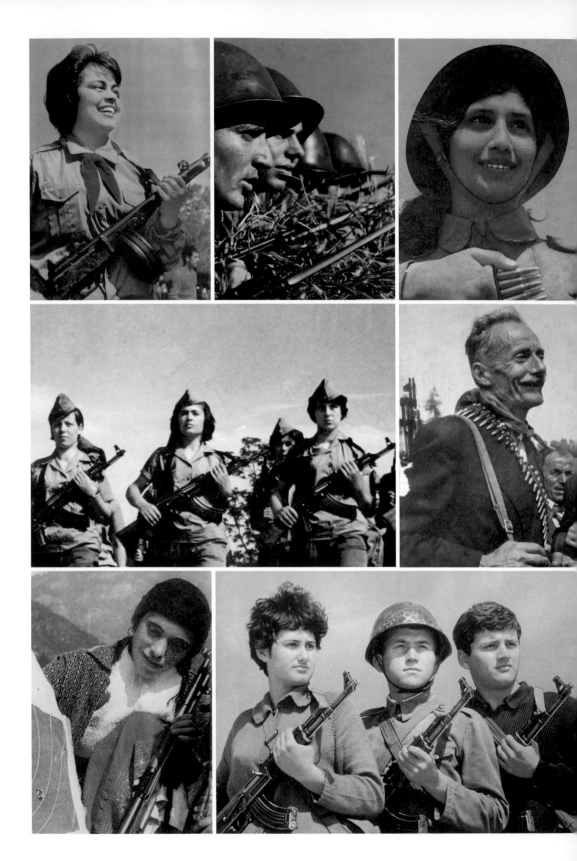

Parku pranveror.

Refik Veseli
P. Sulo.

Springtime Park, Refik Veseli, Pleurat Sulo, August 12, 1970

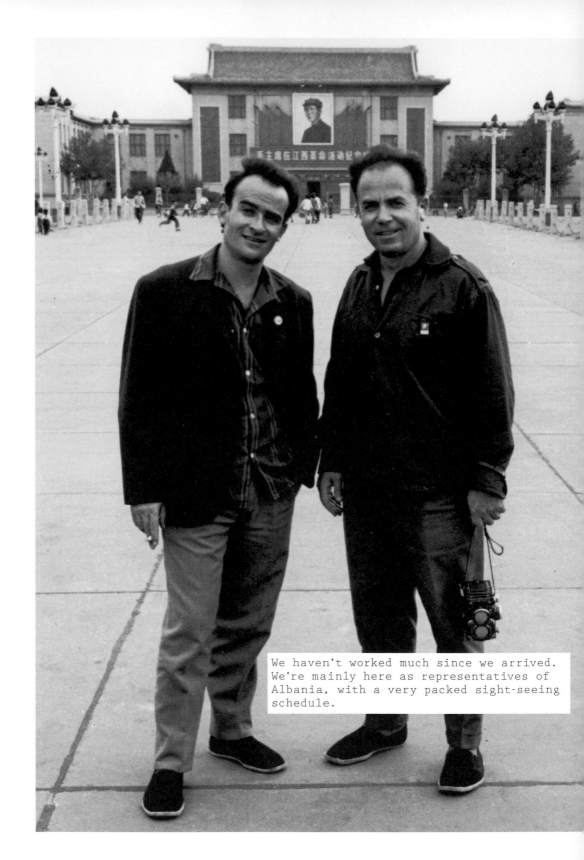

We haven't worked much since we arrived. We're mainly here as representatives of Albania, with a very packed sight-seeing schedule.

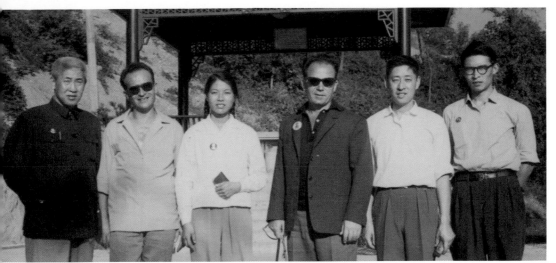

The Chinese have provided us with new cameras: a "Red Flag" for each of us, the local replica of the Leica.

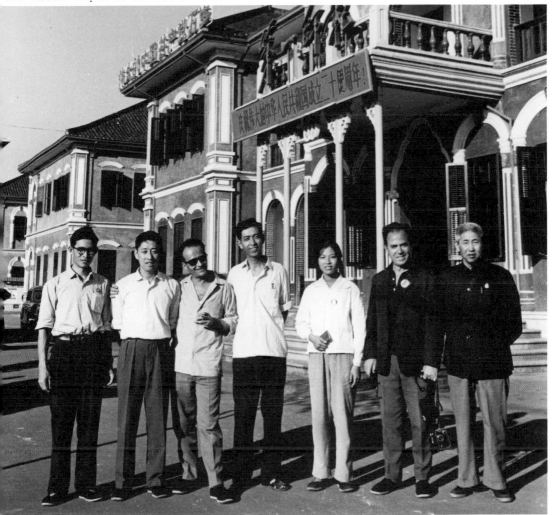

LET'S CELEBRATE THE SECOND ANNIVERSARY OF THE CHINESE REVOLUTION!

The scenes to be photographed are also provided.

★SITE OF THE FIRST MEETING OF THE CHINESE COMMUNIST PARTY

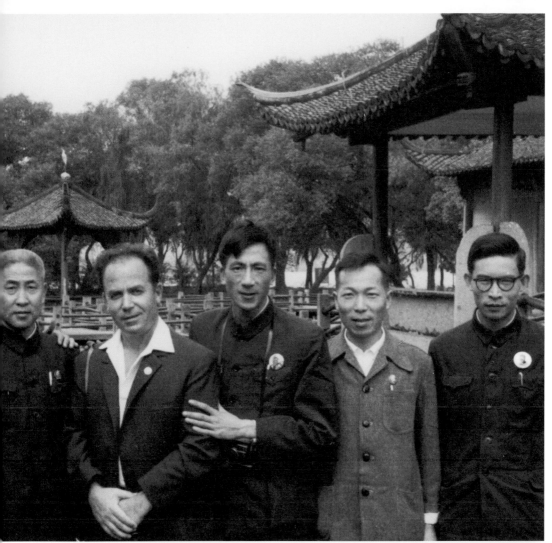

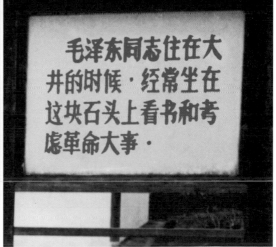

毛泽东同志住在大
井的时候，经常坐在
这块石头上看书和考
虑革命大事。

*WHEN COMRADE MAO LIVED IN DAJING, HE SAT IN THIS
PLACE TO THINK AND READ ABOUT THE REVOLUTION

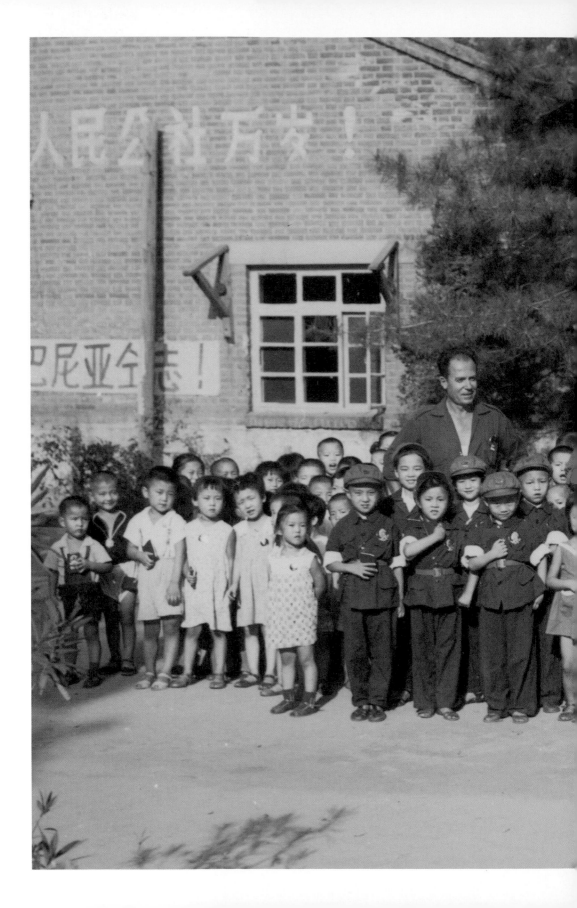

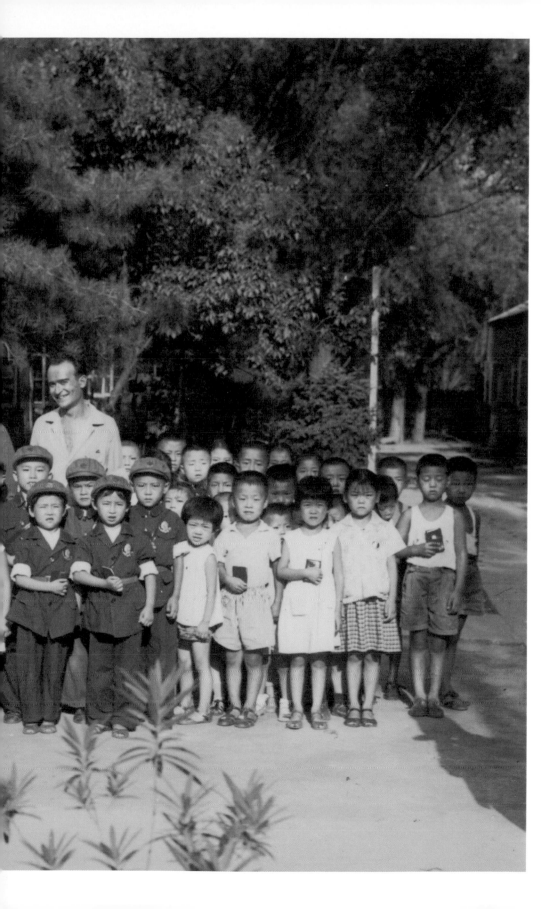

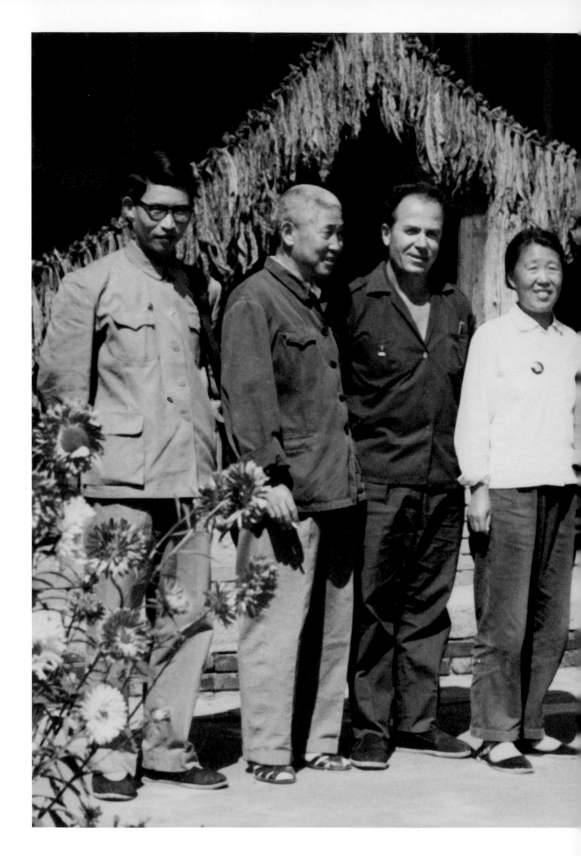

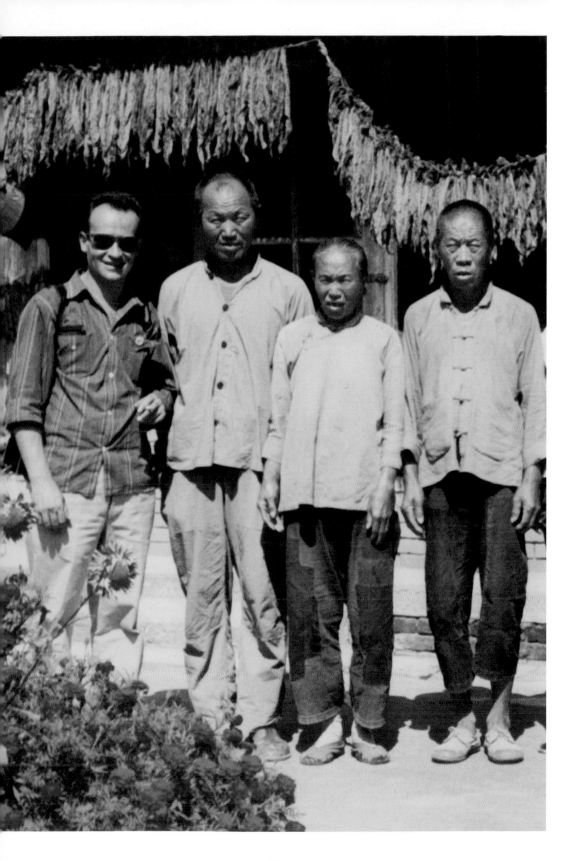

Katjusha doesn't attend the same trainings as us. The Chinese have nothing to teach her, she says. There are rumors that she's already requested another assignment. In Italy! It is an unimaginable destination for us, even as the propaganda photographers closest to power.

None of us is persuaded by this outdated and complicated method. We hope they won't take away our Kodak film.

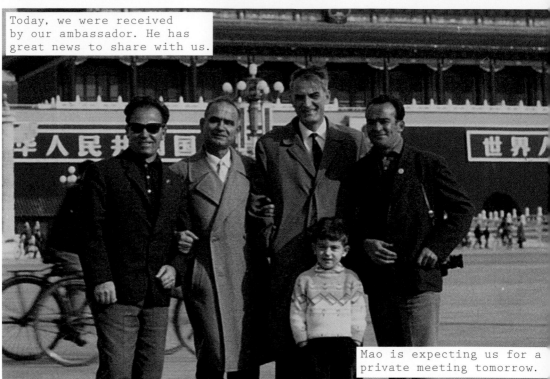

Today, we were received by our ambassador. He has great news to share with us.

Mao is expecting us for a private meeting tomorrow.

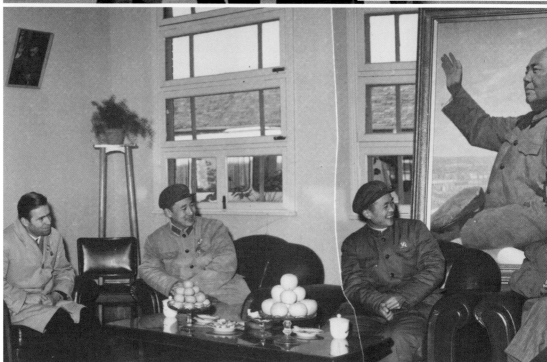

The ambassador reminds us of the security protocol. In a few hours, Mao's private guards will come and collect our cameras. They will be dismantled in order to verify that they contain no weapons or explosives, and then returned to us at the reception.

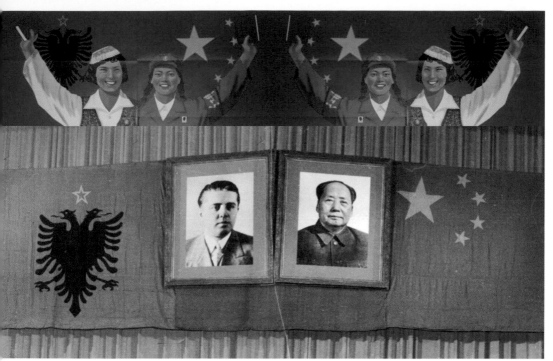

We review again the doctrinal framework: the eternal friendship between
our two brother countries is new but nevertheless regarded with the utmost
solemnity.

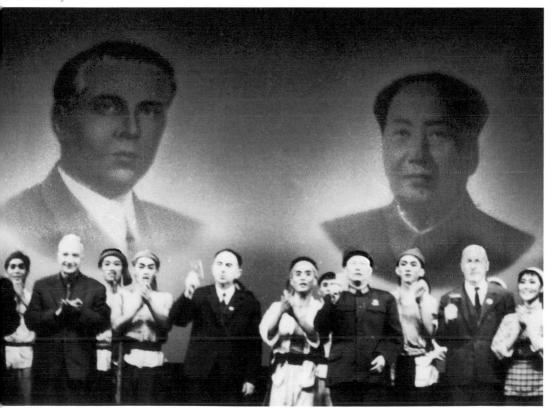

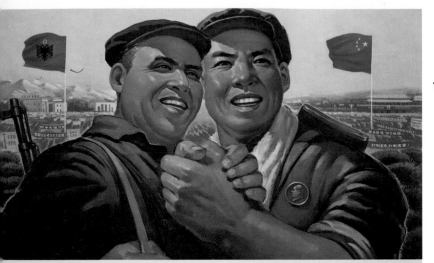

中阿两国人民永恒的、牢不可破的战斗友谊万岁！

**HU JAO PAN
PRESIDENT OF THE DELEGATION
OF THE ASSOCIATION OF
THE CHINESE-ALBANIAN FRIENDSHIP**

The Chinese people witness the figh of the Albanian people with admiratio It is only eighteen years since Albani was liberated. Eighteen years is hardl anything in the history of humanity, bu the Albanian people, gifted by gloriou revolutionary traditions and hardene through so many struggles, unde the rightful direction of the Party o Labour of Albania with Comrade Enve Hoxha at their helm, have achieve brilliant success. Fighting with th firmest determination, the Albania people have transformed Albania fror a poor and backward country int a flourishing Socialist state. Heroi Albania is a glorious member of th socialist camp; she stands heroically a its southwestern outpost. The steadfas Albanian people oppose imperialism" politics of war and aggression wit the fiercest determination, particularl that of American imperialism. The firmly oppose the modern revisionisr represented by Tito's traitorous coteri They unfailingly demand the purity c Marxism-Leninism — always activel supporting oppressed peoples an their struggle for national liberatio working continuously toward th peaceful coexistence between countrie of different social systems and strivin tirelessly for peace around the world. Th Chinese people feel pride and admiratio for the heroic spirit of their dea companion in arms, the Albanian peopl

LONG LIVE THE ETERNAL AND INDESTRUCTIBLE FRIENDSHIP BETWEEN THE ALBANIAN PEOPLE AND THE CHINESE PEOPLE!

CONGRATULATORY SPEECH BY COMRADE KANG SHENG, HEAD OF THE CHINESE COMMUNIST PARTY

Dear comrades!

The Communist Party of China jubilantly greet this congress of yours. We extend our proletarian revolutionary salutations to you! More than five years have elapsed since the Fourth Congress of the Albanian Party of Labour. They have been years of acute and complicated class struggle in the world and years of sharp struggle between Marxism-Leninism and modern revisionism. During these five years, the heroic Albanian people have fought valiantly and unswervingly against foreign and domestic class enemies and won great victories. And they have scored further brilliant achievements in socialist construction and socialist revolution. The Albanian Party of Labour headed by Comrade Enver Hoxha is a long-tested revolutionary Marxist-Leninist Party, a Party that enjoys high prestige in the international communist movement and remains loyal to proletarian internationalism and to the people. Holding aloft the anti-imperialist banner, the Albanian Party of Labour firmly opposes the U.S. imperialist policies of aggression and war and firmly supports the Vietnamese people's war against U.S. aggression. Socialist Albania is a staunch shock brigade opposing imperialism and supporting world revolution. At present, the center of gravity of the U.S.-Soviet collaboration to suppress the revolutionary struggles of the people of the world lies in their joint plot to stamp out the Vietnamese people's war against U.S. aggression and for national salvation. U.S. imperialism has suffered one defeat after another in its war of aggression against Vietnam while the Vietnamese people are growing stronger and stronger in battle. U.S. imperialism is vigorously pushing ahead its plot for "peace talks" while redoubling its efforts to escalate the war. The anti-China heroes and warriors will come to no good end. Those who oppose China most vehemently will suffer the most miserable defeat. As a Marxist-Leninist Party, the Chinese Communist Party is not at all afraid of being isolated and indeed never will be isolated.

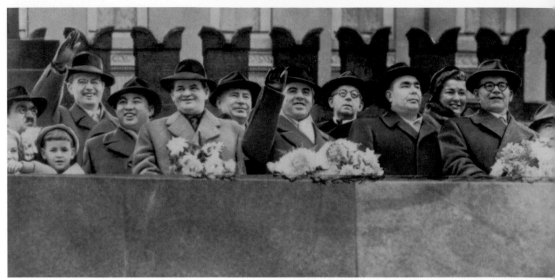

It is an ongoing dance between the delegates of our two countries.

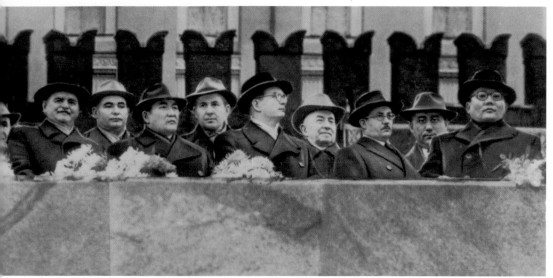

We are there at every turn to capture "the decisive moment"... or at least construct it a posteriori.

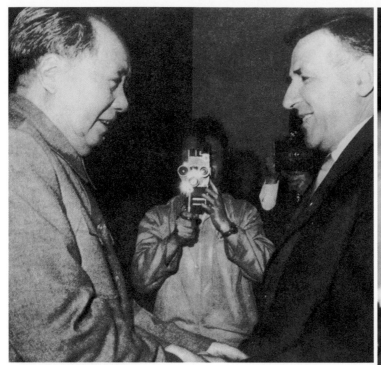

A friendly exchange between comrade Mao and comrade Mehmet Shehu.

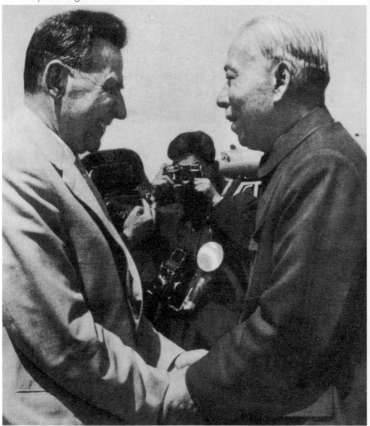

Comrade Mehmet Shehu is welcomed by comrade Liu Shao Li at the Beijing airport.

They meet and become friends. From left to right: Anika Treska (Albania), Daniel Breys (Ghana), and Huang Xiaoman (China).

We know exactly which subjects we are forbidden to discuss.

The ambassador reassures us — we should simply limit our comments to general remarks on tourism.

And if we are asked our opinion on socialist realism?

Our answers have already been prepared:

Over the last few years, China's support has been crucial to the development of our country. The Chinese have helped us in the construction of power plants, steel factories, textile factories, and refineries...

Our country's industrialization is rapidly advancing.

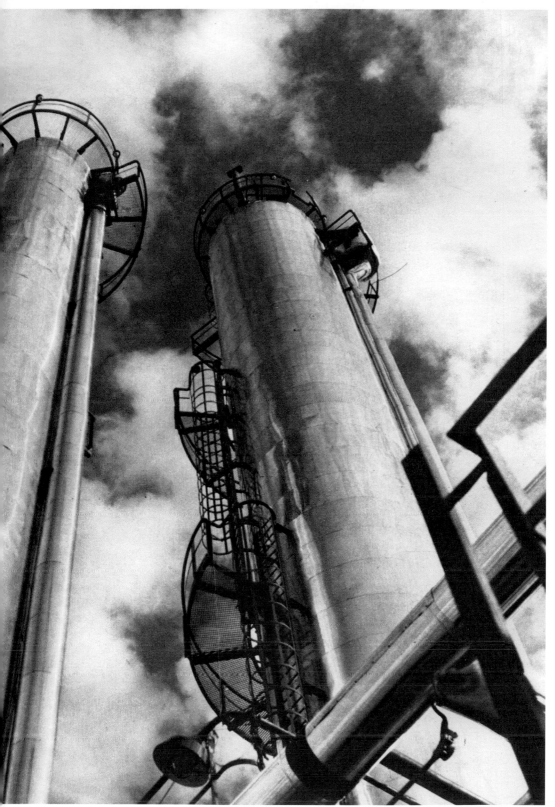

"Iron towers 'besiege' the heavens." Nitrogen fertilizer plants in the Fier District.

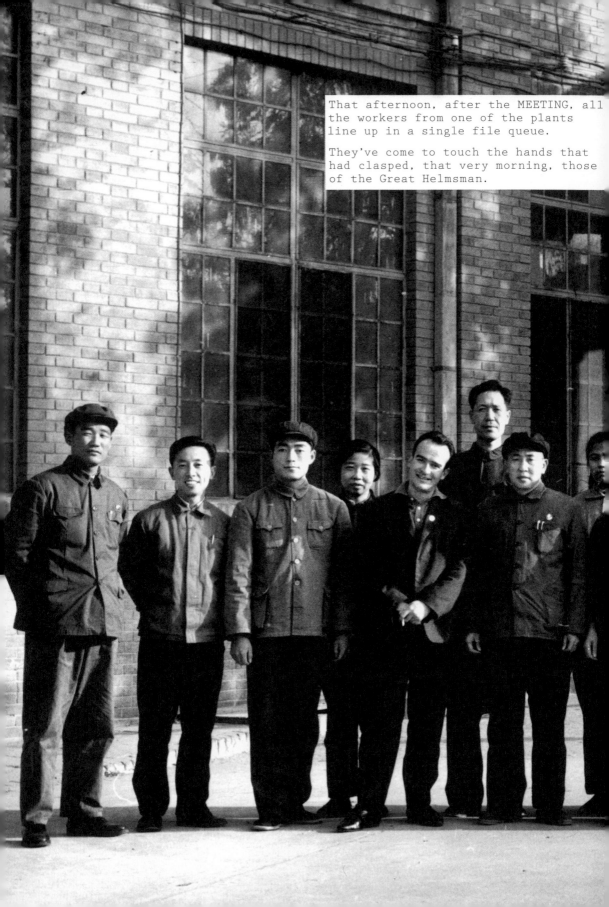

That afternoon, after the MEETING, all the workers from one of the plants line up in a single file queue.

They've come to touch the hands that had clasped, that very morning, those of the Great Helmsman.

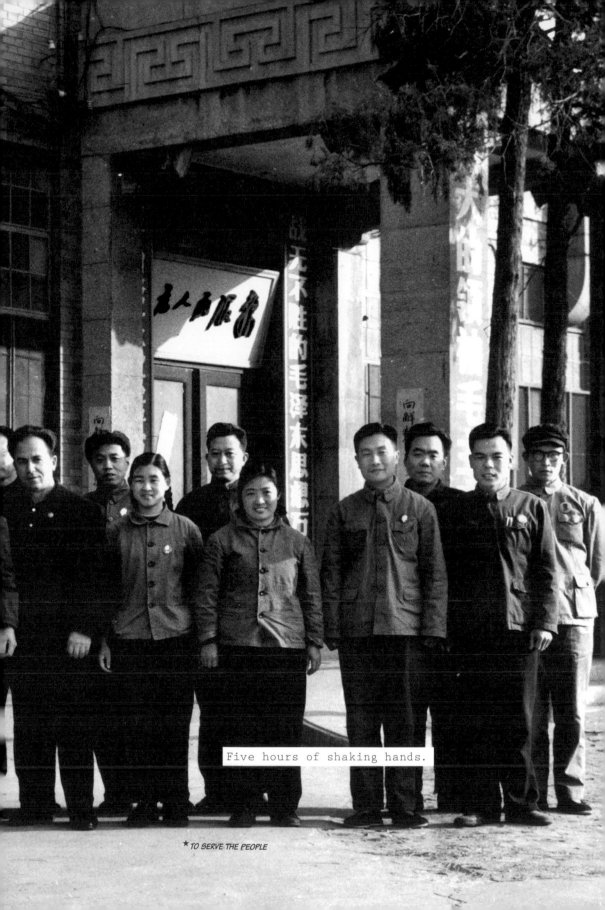

Five hours of shaking hands.

*TO SERVE THE PEOPLE

We had posed for pictures with
Mao that morning too. Not that
any exist now.

We burned them.

First incident?
Yesterday I said
something I thought
was completely
harmless.

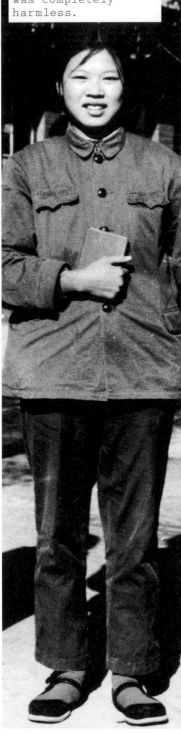

I'd asked our translator if she'd ever been to
Tirana before. I had the impression of having seen
her in a photograph. Uncomfortable silence.

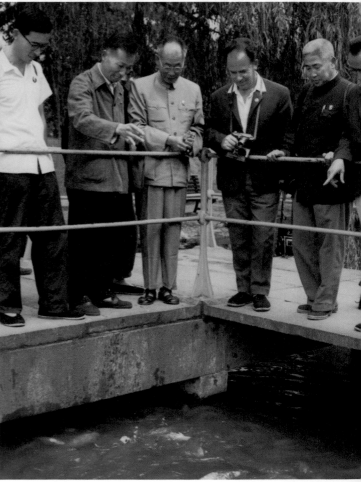

At first she denied it but was quickly signaled to
say nothing more.

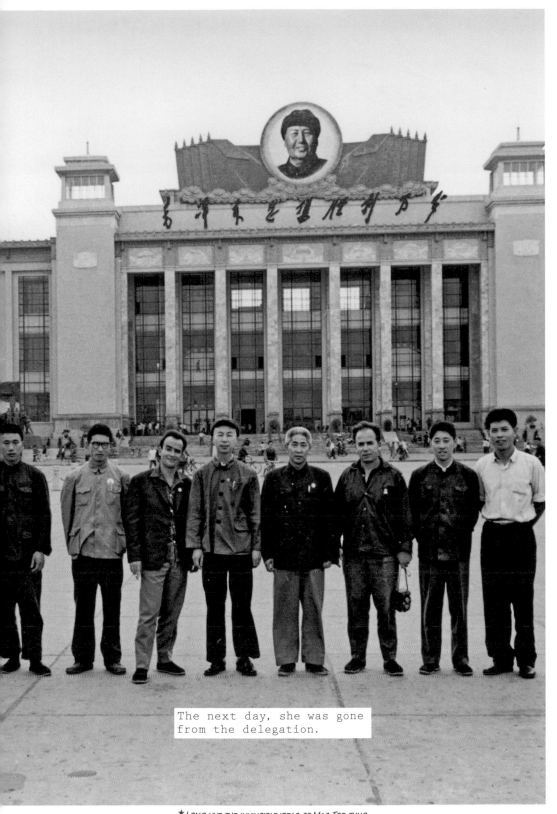

The next day, she was gone from the delegation.

★ LONG LIVE THE INVINCIBLE IDEAS OF MAO TSE-TUNG

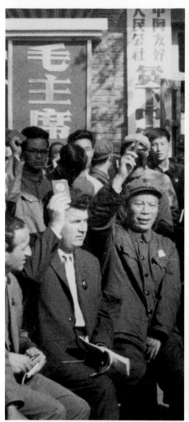
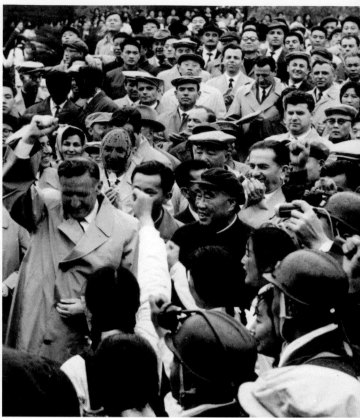

Our embassy sends repeated orders to disclose nothing to our hosts.

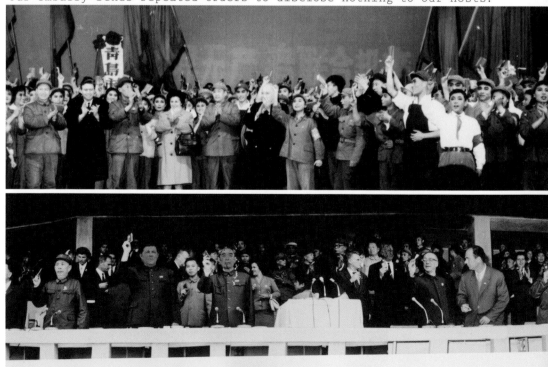

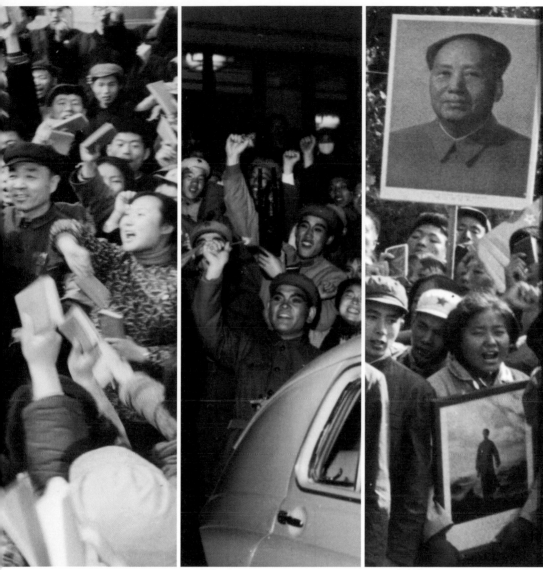

The Albanian leadership is deeply troubled by the Cultural Revolution. They are as terrified by the appearance of the Red Guard as they are by the open criticism and systematic purging of so many senior officials.

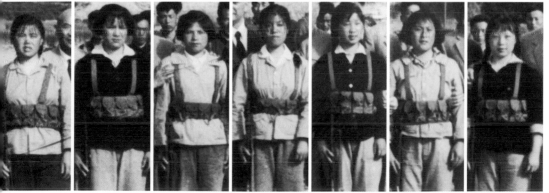

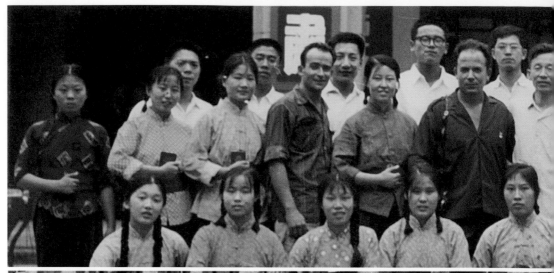

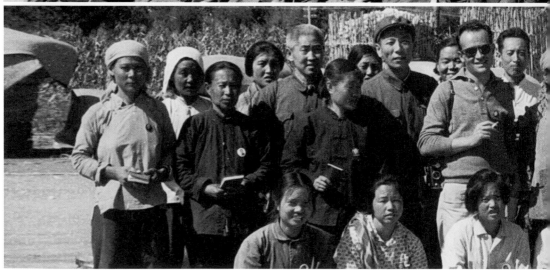

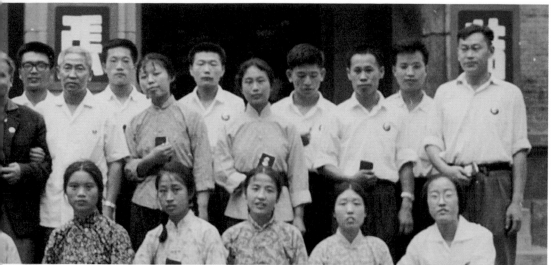

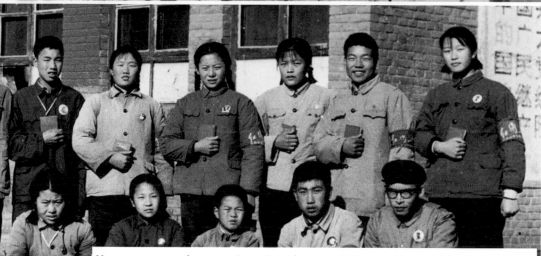

We are warned to maintain the strictest silence while we're here and just as much when we get back home: the Albanian people must never learn about the situation in China.

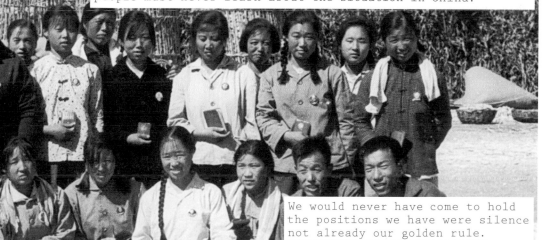

We would never have come to hold the positions we have were silence not already our golden rule.

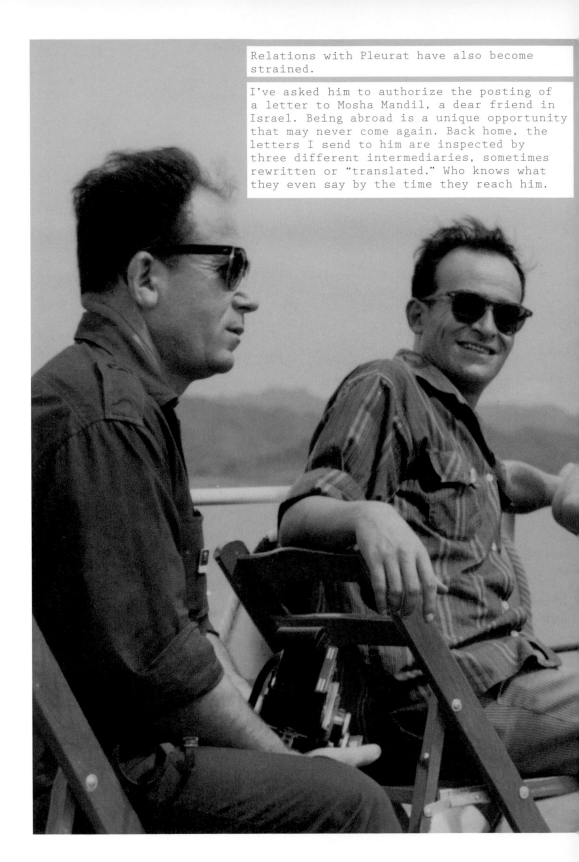

Relations with Pleurat have also become strained.

I've asked him to authorize the posting of a letter to Mosha Mandil, a dear friend in Israel. Being abroad is a unique opportunity that may never come again. Back home, the letters I send to him are inspected by three different intermediaries, sometimes rewritten or "translated." Who knows what they even say by the time they reach him.

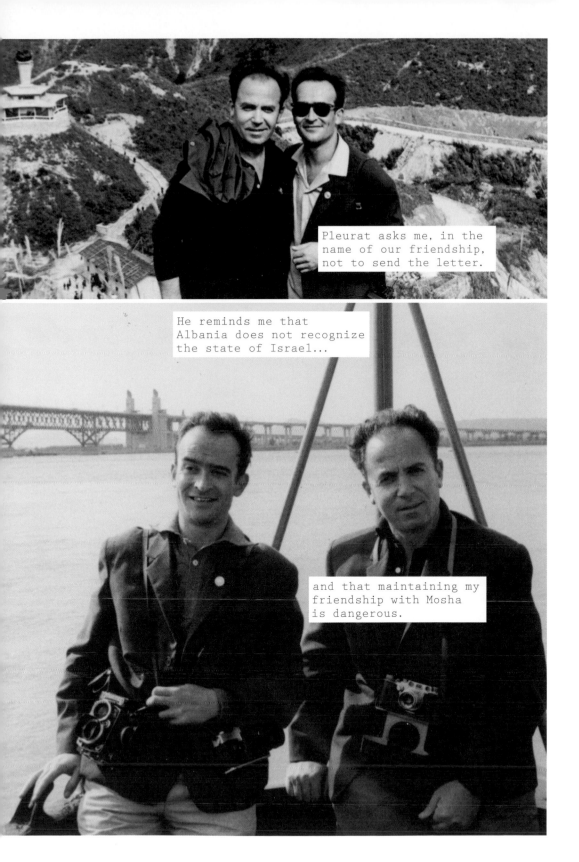

Pleurat asks me, in the name of our friendship, not to send the letter.

He reminds me that Albania does not recognize the state of Israel...

and that maintaining my friendship with Mosha is dangerous.

He reminds me of my already tainted biography:

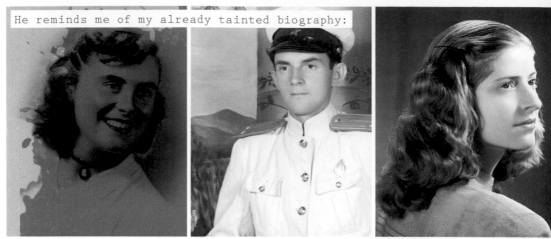

My private studio in Tirana, *Studio Sporti*, that I kept open for as long as I could, even after every other photographer had joined the state collectives.

It is a blemish on my record: "operative of private commerce."

Nevertheless, due to my technical knowledge — earning me the title of *mjeshtër*, master of photography — I have become one of the official photographers of the regime. I am regularly called on to take portraits of comrade Enver...

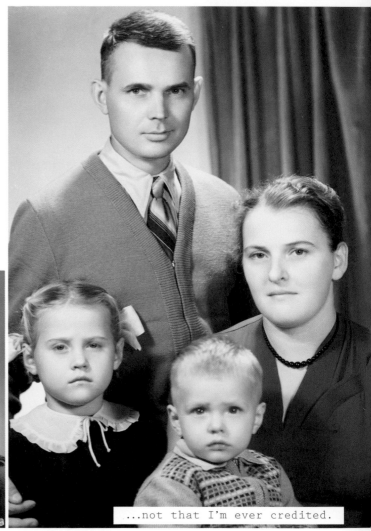

...not that I'm ever credited.

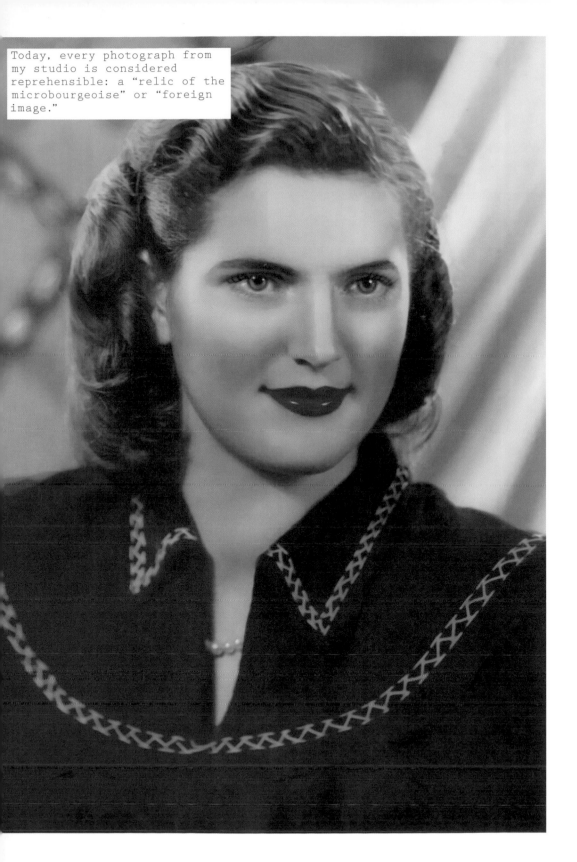

Today, every photograph from my studio is considered reprehensible: a "relic of the microbourgeoise" or "foreign image."

Pleurat tells me that
the situation is even
worse now, that a letter
from Enver Hoxha in
Zëri i popullit has
raised the question of
photographers' private
collections.

Dear comrade Gegë Marubi,

I have learned through your recent letter as well as the article by Fadil Kraja in the journal *Zëri i popullit* that you have awarded the state your vast archive of photographs taken over 85 years, an archive that tells the History of our people, at the service of which your father — driven by his patriotism — worked his entire life. Dear Gegë, you have continued the work of your father, both in preserving and enriching this time-honored collection of 85 years, and now in choosing to deliver it to the Albanian people. I salute this patriotic gesture, one that is deeply valued not only by the residents of Shkodra, but by the nation in its entirety. This act will inspire other patriots who have kept similar treasures for themselves to release their collections to the State for the good of the Nation and its people.

Enver Hoxha
September 1970

I have thousands of
plates from *Studio
Sporti*. I will never
give them up.

"Abandon the idea of
this letter," Pleurat
insists.

He does not understand
what Mosha Mandil and
I have been through
together.

Scrapbook,
the Mandils

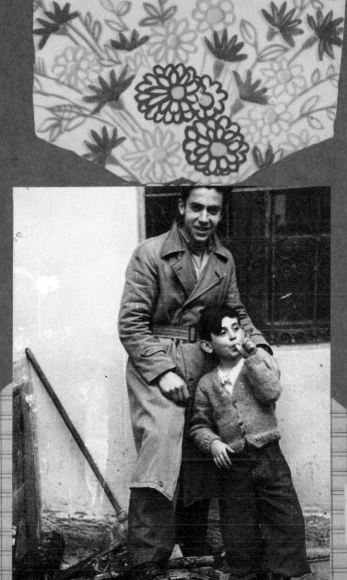

With Gavra Mandil, Mosha's oldest son. I am 20 years old.

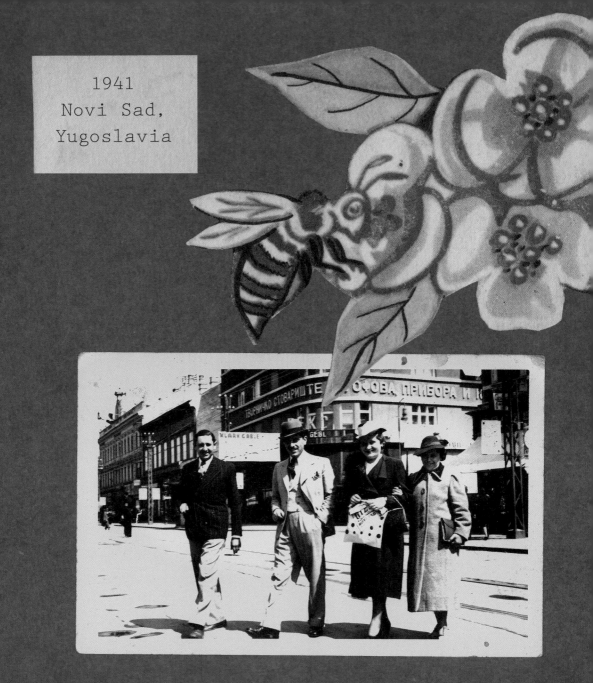

1941
Novi Sad,
Yugoslavia

The Mandil family in Novi Sad. Mosha Mandil and his father-in-law are the official photographers for the Voïvodine province state court.

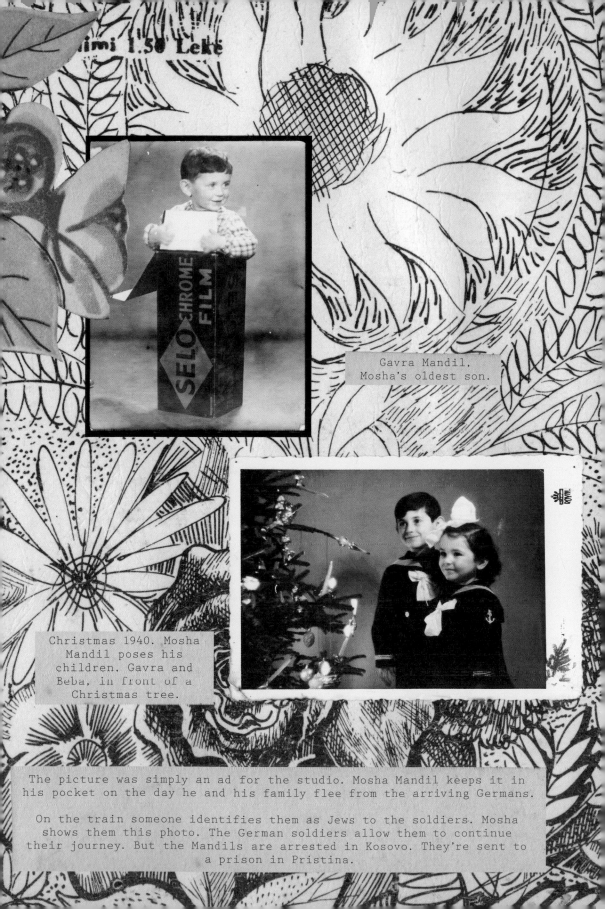

imi 1.50 Lekë

SELO CHROME FILM

Gavra Mandil,
Mosha's oldest son.

Christmas 1940. Mosha
Mandil poses his
children. Gavra and
Beba, in front of a
Christmas tree.

The picture was simply an ad for the studio. Mosha Mandil keeps it in
his pocket on the day he and his family flee from the arriving Germans.

On the train someone identifies them as Jews to the soldiers. Mosha
shows them this photo. The German soldiers allow them to continue
their journey. But the Mandils are arrested in Kosovo. They're sent to
a prison in Pristina.

The Mandils spend ten
months in this prison,
under the Italian guard.
Mosha offers to take the
soldiers' pictures. Many
want to be photographed
in uniform.

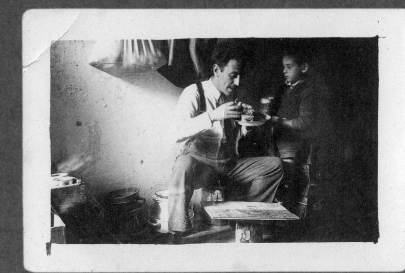

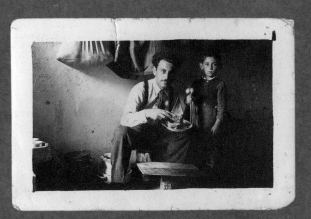

Mosha and Gavra Mandil

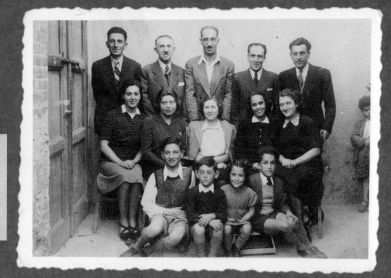

Mosha is placed under
confino libero in Kavajë,
a few kilometers from
Tirana. He must report
daily to the Italian
authorities, but he is
allowed to work.

He tracks down Ismail Neshid, one of his old
apprentices, who offers him work in his studio as
a lighting assistant. It is a job far beneath his
training. I've been apprenticing at Neshid's studio
for three years. We become friends.

Mosha on the streets of Tirana.

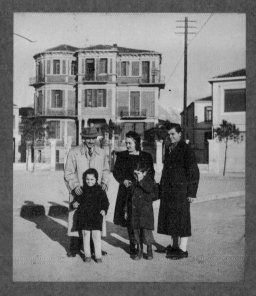

September 1943: The Mandils and
my brother. The first meeting to
plan their escape to Kruja.

The Germans are taking over for Italy. It isn't
a matter of *confino libero* anymore.

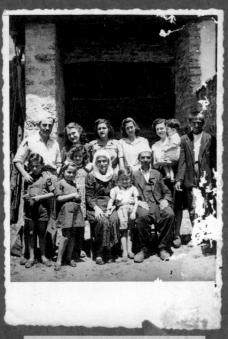

Papa, Mama, the Mandils.

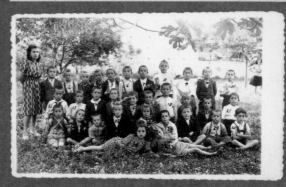

Spring 1944.
Gavra (first row, right) school day.
He's supposed to be my little brother.

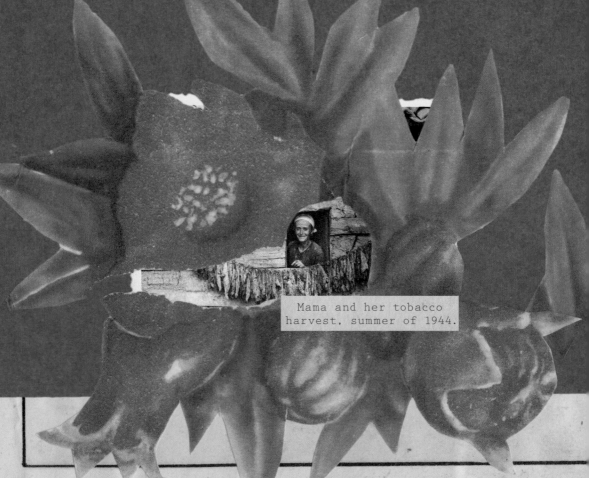

Mama and her tobacco
harvest, summer of 1944.

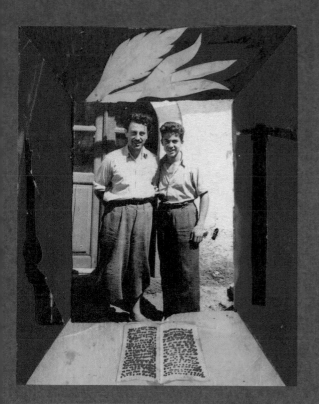

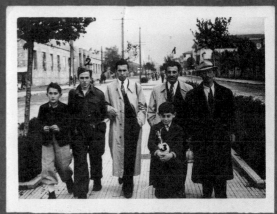

November 1944, Tirana.
(1) Mosha, (2) Me in uniform,
(3) Gavra

With Mosha (left) finally
out of hiding in the
basement: freedom!

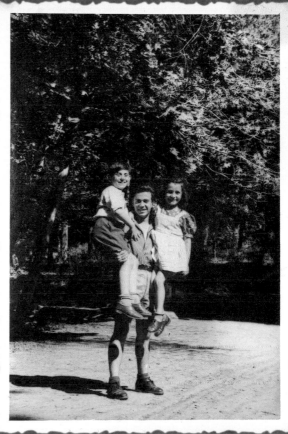

With Gavra and Beba.
Mosha has offered to help
me complete my photography
training in Yugoslavia. It won't
be long before I join them...

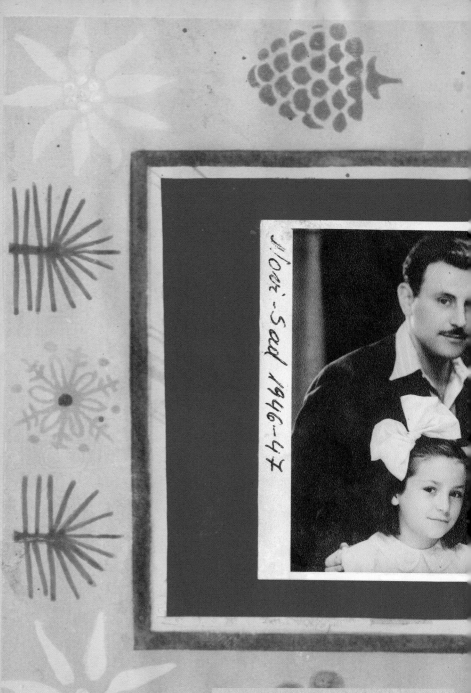

Port-Said 1946-47

Momento from my
apprenticeship in Yugoslavia:
at top, Mosha and I,
below, the children Beba and
Gavra, and Mosha's wife Elika.

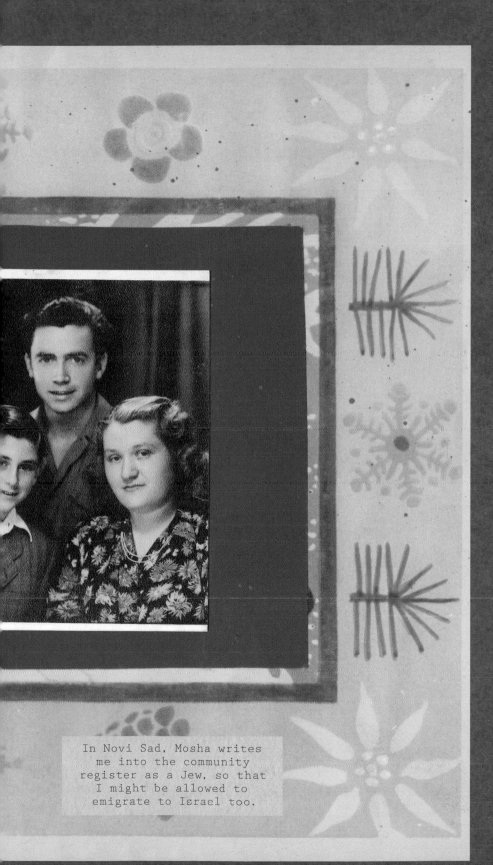

In Novi Sad, Mosha writes
me into the community
register as a Jew, so that
I might be allowed to
emigrate to Israel too.

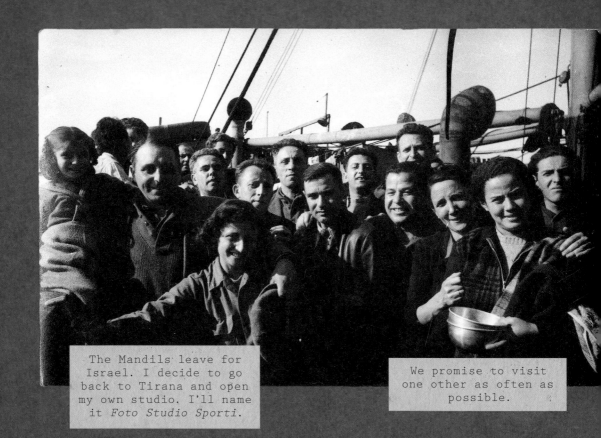

The Mandils leave for Israel. I decide to go back to Tirana and open my own studio. I'll name it *Foto Studio Sporti*.

We promise to visit one other as often as possible.

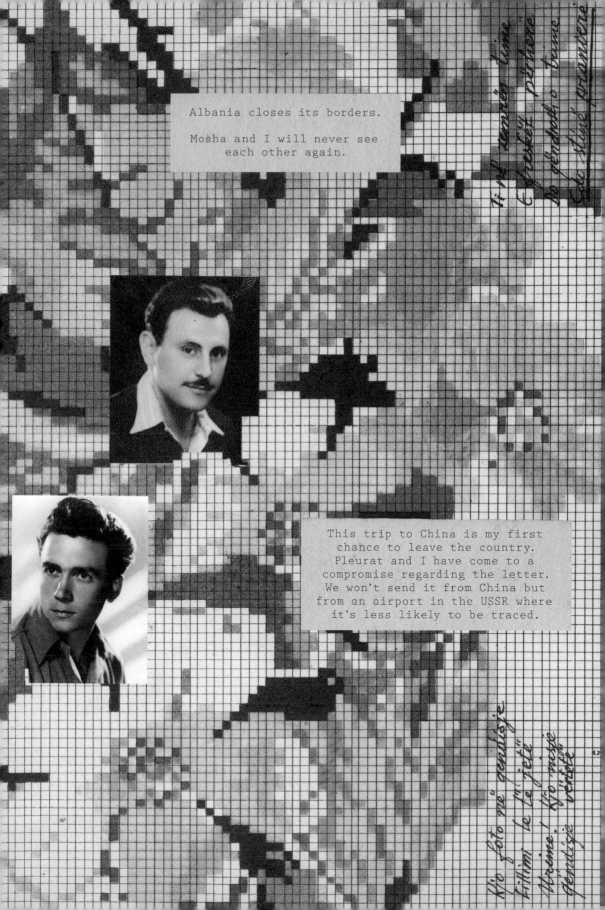

Albania closes its borders.

Mosha and I will never see each other again.

This trip to China is my first chance to leave the country. Pleurat and I have come to a compromise regarding the letter. We won't send it from China but from an airport in the USSR where it's less likely to be traced.

1

25.8.84.

Dear Refiku and family,

I was very glad to receive your last letter a few weeks ago. As always, you write to me a lot of interesting and nice things. But you also forget to give me the answers about some subjects that I ask. you. For example: I told you, in my last letter, that some of the Jewish people, who were saved during the war in Albania by the Albanian people, and live today in Israel - getthered in my home to decside what can we

August 25, 1984

Dear Refik and family,

I was very glad to receive your last letter a few weeks ago. As always, you write to me a lot of interesting and nice things. But you also forget to give me the answers about some subjects that I ask. For example: I told you, in my last letter, that some of the Jewish people, who were saved during the war in Albania, by the Albanian people, and live today in Israel — gathered in my home to decide what can we do to express and show our gratitude for that generous and human gesture of the Albanians. I asked your opinion in what way can we do something and if there could be any official way to thank Albania for what she did for us. And you ignore the whole subject and do not mention even a word about it! . . . Or another thing: I have been asking you in my letters — who is writing for the letters in such a good English? (Because I can see it is not your hand-writing.) And you do not give me the answer . . . I am very interested to know what your answers are to these matters, particularly your reaction about the meeting we had here, in my home, and if you have any suggestions what we could do to express our thanks and gratitude to the Albanian people.

Now about the other things in your letter. I realize perfectly that Albania has made a great progress and has changed a lot in the last 40 years! But I was not sure if you could get KODAK materials and chemicals over there. And was very glad to read in your letter that you too are using the most modern and up-to-date materials and equipment! I also use KODAK Ektachrome 64 films; do my own E-6 and C-41 processing; I also enlarge my own prints in colour and black&white, of course; and I also do CIBACHROME prints from colour transparencies. So, there is not much difference between your systems of work and mine.

For 120 roll-films I use the "HASSELBLAD" camera with all its lenses and accessories. And for the technical work I also use "LINHOF-Kardan-color" 4x5 (9x12 cm) camera with sheet-films. In the studio I use electronic flashes for lighting. And I also shoot quite a lot outdoors on location.

I would very much like, if it could be possible, to go to Albania and see for myself all the changes and progress that took place in the past 40 years, since I was there as a child. I would also like very much to see you and your family, and see the changes in all of you! Do you think it could be possible??? I would love to come and see you all there! I am enclosing a picture of the house where we lived in Kavaja, for you to know which house to photograph if you go there . . .

I was very happy to read in your letter that almost everybody in your family is a photographer! Your wife Drita, your two sons and even your son-in-law. It is wonderful, and I was deeply touched to read that you feel and think that it is all thanks to my Father! I know that he too felt grateful for all that you and your family have done for us during the war, and he wanted to repay back, even partly, what he felt he owed you — by teaching the photographic profession. He would be glad to know that his intention and wish has been fulfilled — if he was alive. He would have been very glad, I am sure, to know that you have passed on what he has taught you — onto your children! And on his behalf — I am expressing my happiness and satisfaction!

In our family, we are all well: my mother Elika is fine, she still works at her studio in Haifa. I showed her your letter and she promised she will write to you. Beba and her family are also O.K. Her older son studies now in Colombia (!) — at the other end of the world . . . Ron, my son, is now in an officer's course. It is very difficult for him, but at least he is not in Lebanon! . . . Tammy, my older daughter, has finished her grammar school and is also going to the army for two years! So now we shall have two children in the Army . . . Ruthi, the little daughter, is 12-1/2 years old, she dances ballet in a group, and she still makes Noemi and me parents to small children . . .

I am busy at work in the studio and with teaching photography in a college in Jerusalem. I am quite happy with my work, because my Father has passed on to me, like on to you — the love for my profession.

By the way: do you all work together in the same photographic firm? I mean you, your wife, your sons, and your son-in-law?? Do you have your own studio and . . .

in a group, and she still makes Noemi and me parents to small children...

I am bussy at work in the Studio and with teaching photography in a College in Jerusalem. I am quite happy with my work because my Father has passed on to me, like on to you — the love for my proffession.

By the way, do you all work together in some photo firm? I mean you and your wife, your sons and your son-in-low ?? Or do you have your own

Gavra Mandil's letter to Yad Vashem, nominating the Veseli family for the distinction of "Righteous among Nations," June 1987

After many years of hesitation and delay due to my lack of knowledge about what needed to be done and how I was to deal with the matter – it is only now that I am taking upon myself to write to you and tell you an important story of the Holocaust time. I am doing it for two reasons:

A. Because I want to inform you about a story of the Second World War that is not so well known in Israel in order for it to be registered, documented and kept in your archives.

B. Because I want to nominate a man for the title of Righteous Among the Nations, who during the Holocaust saved my family and other Jewish families. He lives in Albania and we have kept in touch until these very days.

I was born in Belgrade, Yugoslavia in 1936. When the Germans invaded, I was four and a half years old. My father refused to register his family with the Germans as the law required and as many other Jews did, and with the help of Serb friends, we escaped with forged papers to southern Yugoslavia, to the area under Italian rule. Shortly afterwards Jews were being arrested and put in the town jail of Pristina, that in part became a concentration camp for Jews. My father, mother, my young sister (two and a half years my junior) and I were one of some one hundred Jewish families that were incarcerated in that camp. During the time we stayed there – for almost a year – groups of Jewish families were taken to be killed, allegedly to alleviate the crowded conditions. In June 1942 at the initiative and under the leadership of my father and with the help of the Italians in charge of the camp, but without the knowledge of the Germans and contrary to their instructions, a group of 120 Jews

was exiled to Albania, which was also under Italian occupation. In Albania the Jewish families from Yugoslavia were dispersed in different towns. There was an obligation to present oneself every day to the authorities, but there was relative freedom of movement within the town – what was called *confino libero* by the Italians. Thus we lived in relative comfort until Italy's surrender in the middle of the Second World War in autumn 1943.

When the Germans came to Albania, the Jews had to escape to the mountains, to the forests and remote Albanian villages. In those difficult times the Albanian people revealed themselves in their full glory and greatness. There was not one Jewish family that failed to find shelter within the Albanian local population, whether with poor villagers or with owners of estates and manor houses. No Jew remained without the protection of an Albanian. In many cases, like our own, the hiding of Jews involved the danger of death and required colossal self-sacrifice! Our family of four and another Jewish family of three was saved thanks to the shelter we found at

the home of the Veseli family in a small village called Kruja in Albania. Like us, all the Jewish refugee families from Yugoslavia who were in Albania in those years were saved. Most of Albania's survivors emigrated to Israel and live here today.

The Albanians are simple people, but very kindhearted, warm and humane. They may not have been educated on the heritage of Goethe and Schiller, but they attached the greatest importance to human life, in a most natural and unquestioning way. In those dark days, when Jewish life in Europe didn't count for much, the Albanians protected the Jews with love, dedication and sacrifice . . .

Gavra Mandil and
Refik Veseli,
July 1990.

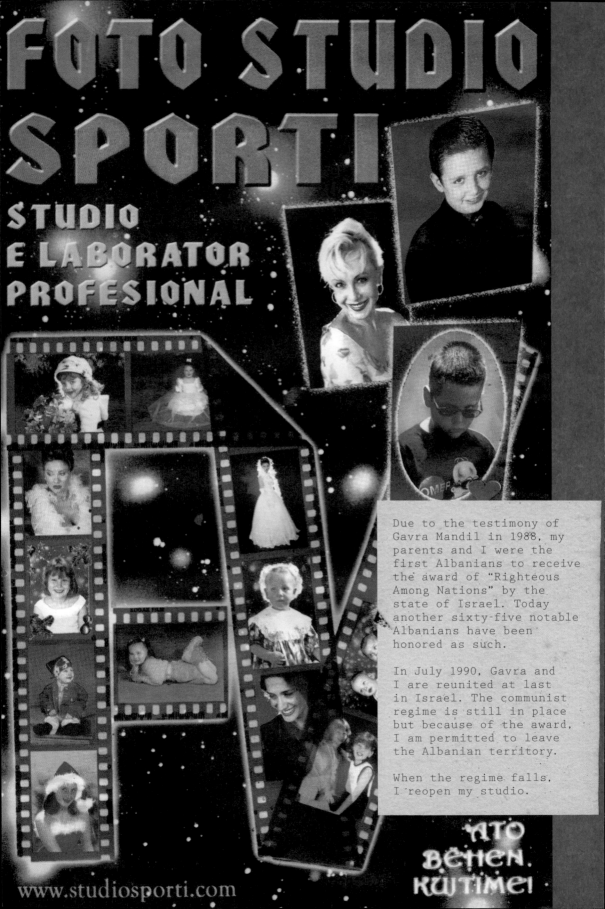

FOTO STUDIO SPORTI

STUDIO E LABORATOR PROFESIONAL

Due to the testimony of Gavra Mandil in 1988, my parents and I were the first Albanians to receive the award of "Righteous Among Nations" by the state of Israel. Today another sixty-five notable Albanians have been honored as such.

In July 1990, Gavra and I are reunited at last in Israel. The communist regime is still in place but because of the award, I am permitted to leave the Albanian territory.

When the regime falls, I reopen my studio.

ATO BEHEN KUJTIMEI

www.studiosporti.com

EPILOGUE

1978
BREAK IN THE DIPLOMATIC RELATIONS BETWEEN CHINA AND ALBANIA

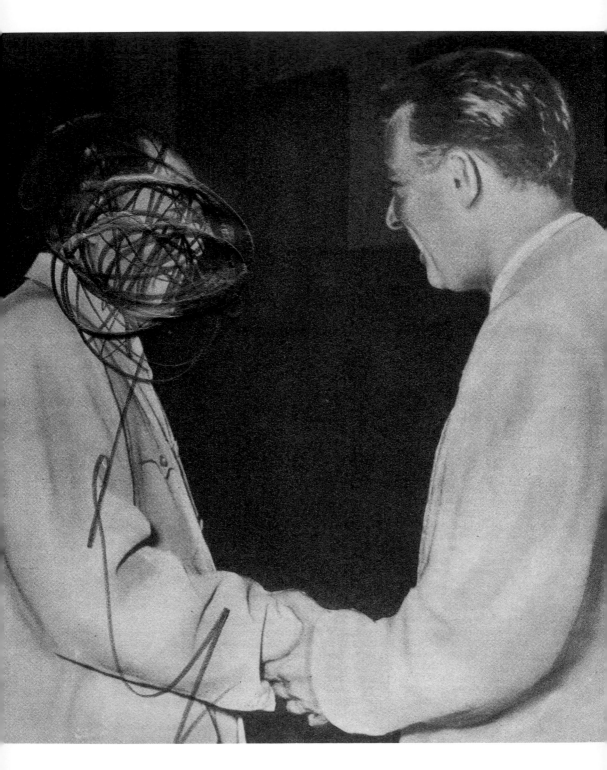

THE CULT OF MAO TSE-TUNG

MARX denounced the cult of personality, considering it a repugnant practice. Though an individual can at times play an important role in history, for us Marxists, this role cannot compare to the one played by the people, the masses. For it is the people who make history, who bring about revolution, who build socialism. For us Marxist-Leninists, the role of the individual is equally inferior to the great role of the communist party, who acts as the head of the masses and inasmuch guides them. Nevertheless, we have regretfully noticed this month that our Chinese comrades are following a misguided and anti-Marxist path. They have begun to convert the cult of Mao into a quasi-religious cult; they glorify him in an obscene manner with no thought to the great injury that this attitude does to the Cause, to say nothing of the ridicule that accompanies it. This adulation is conducted with such great fanfare and pompous language that everything about it seems orchestrated, and is therefore, for us Marxists, an anachronistic, intolerable and unacceptable practice for our time.

WHEN AND HOW WILL THE CHINESE COLD FRONT END?

Alledgedly "suffering from rheumatism," Mao reported being unable to receive the leader of our government delegation and representative of the Political Bureau, Reiz Malile. Zhou Enlai also reported being "too tired" to visit with Malile. In fact, neither Mao nor Zhou were suffering from ill health or fatigue; the very same day, both men visited with other foreign delegates, providing them with banquets and attending exhibitions.

In years past, Zhou and Mao received even our most rank-and-file public servants. Naturally, their behavior concerns us. We are carefully watching to see how far the Chinese will go in pursuing this attitude toward Albania. Nevertheless, for now, we will maintain our composure; we will continue to act as good friends and comrades to the Chinese people for as long as they themselves continue to act as good Marxist-Leninists toward the Party of Labour and our country. This is in the interest of both sides and supports the necessary Internationalist road forward.

THE CHINESE VIOLATE AGREEMENTS CONCERNING THE SMELTER COMPLEX

The Chinese have turned their backs on our country and our until-now friendly relations. It would seem that, for them, this friendship was built on very different objectives, a friendship to be exploited in times of difficulty, whereas, from our perspective, it was one of sincerity and integrity.

July 29, 1978, Albania announces the collapse of diplomatic
relations with its former friend in a 24-page letter
entitled "Letter from the Central Committee of the Party
of Labour of Albania and from the Albanian government to
the Central Committee of the Communist Party and to the
Chinese government."

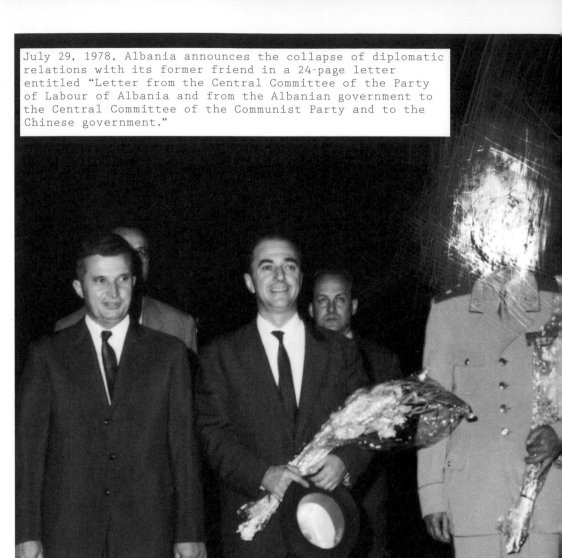

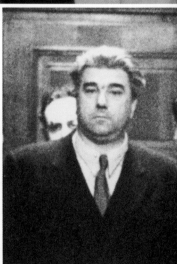

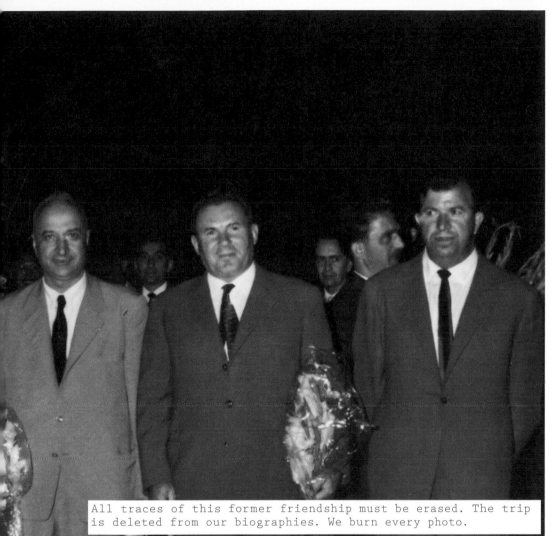

All traces of this former friendship must be erased. The trip is deleted from our biographies. We burn every photo.

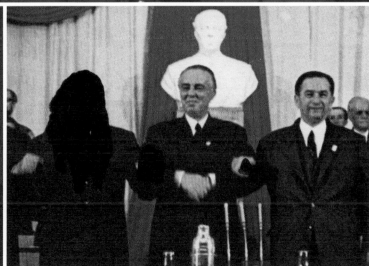

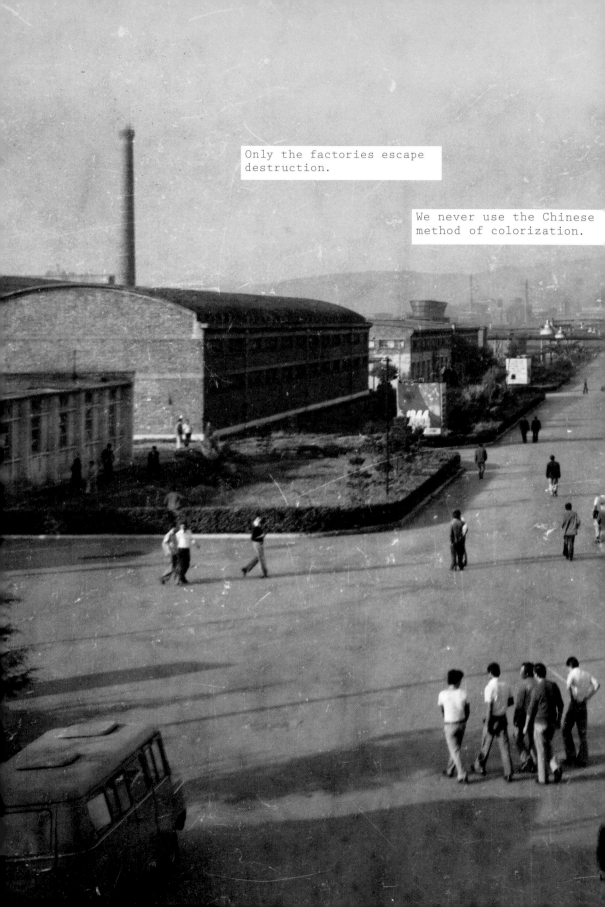

Only the factories escape destruction.

We never use the Chinese method of colorization.

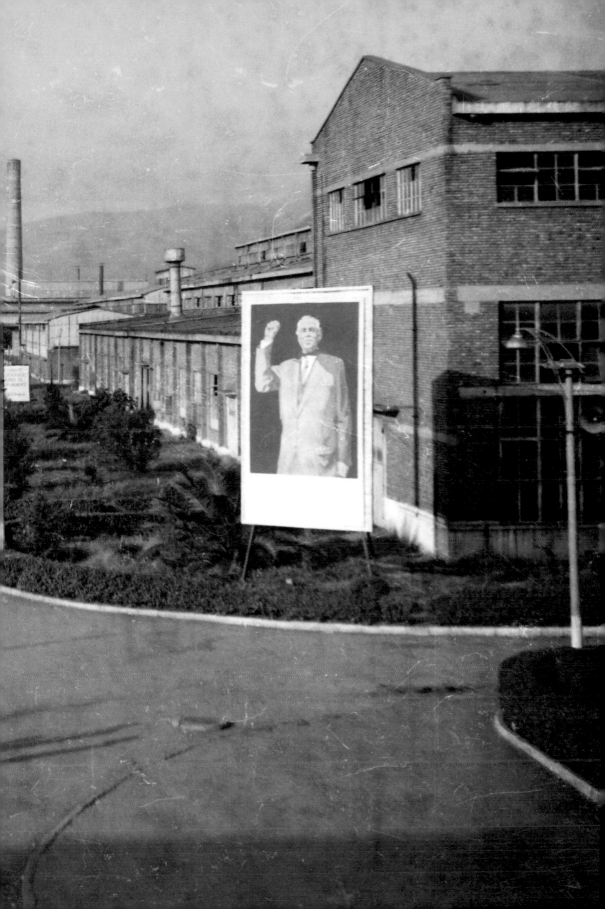

Luftë për fitore.

Foto: R. VESELI

A TRUE STORY

by Gilles de Rapper

In terms of its chronology, characters and details, this account is a true story. It is the result of many years of research into Enver Hoxha's regime (1944-1991) and the immense photographic archives of Albania's communist period. Using original images from those archives, Anouck Durand has succeeded in not only telling the story of a particular man, but in sketching out the necessary landscape of a larger story. Durand nimbly assembles and contextualizes that history throughout the pages of this book. But of course this account is also, in part, a fiction; the narrator Refik died in 2000 before Durand could interview him and record his story in his own words. As to the images, they were likely never intended to figure in the telling of any narrative other than that of their original purpose.

Between 1961 and 1972, Albanian photographers were sent to China to train in methods of color photography. Yet Kodak film was still simultaneously being imported into Albania, and with it, the developments of modern color technology for both state propaganda and the leadership's private use. As a result, as the protagonists in this story affirm, the Chinese technique adapted from the old tri-chrome method of printing was never actually practiced by Albanian photographers. Inasmuch, it was a strange and singular moment in the history of Albanian photography — one that marks a tension between the appeal of Western technology and an ideological loyalty to their Chinese ally — one that the story of *Eternal Friendship* reveals.

In 2008 Anouck Durand and I first went in search of the former propaganda photographers of Enver Hoxha and their archives. We have since collected volumes of photographs that serve to contextualize the photographers' experience — from their formative years to the institutional organization of their profession, from the materials they used to the demands and freedoms of their trade as photographers in the context of a totalitarian regime. We recorded dozens of hours of interviews, transcribed hundreds of pages of notes and observations, and scanned thousands of images. The objective of this research was to sketch out a picture of the photographic production of communist Albania for the purposes of better understanding that output as well as the inner workings of the regime and its continued legacy in the field of production and use of photo images. Indeed, we see here a broad spectrum of those images, from that of the portrait studio to the propagandistic. Taken together, they provide a

unique lens into the complicated private and professional lives of the regime's photographers. The case of Refik Veseli is exemplary in this regard — introduced to photography by the fortunes of war, he became a renowned studio photographer in Tirana and then, after the official closing of all private studios (in the early 1960s), a photographer in the department of archaeology. At the same time, his photographic talents, particularly as a portraitist, provided him with the opportunity to publish in the state propaganda magazines and to participate in the realization of the official portraits of the dictator. Following the regime's fall, he reopened his private studio under the same name *Foto Studio Sporti*. By contextualizing and foregrounding the individual stories of "propaganda photographers" of the Albanian regime, we begin to see beyond reductions of category. Behind these caricatures lies a complex organization of power, heavy with tensions and contradictions, and a multitude of personal trajectories.

None of the photographers we interviewed for our research, including the protagonists in this story, gave any prominence to the trip to China in 1970. Frequently, it was not mentioned at all. A forgotten step along a career path, it would only occasionally come up in conversation, and at that, only piecemeal and in passing. How is it possible that several months abroad — in the huge expanse that is China during the era of Mao, at a time when it was exceedingly unusual to be permitted to travel outside of Albania — could become an anecdotal mention, neglected or even eschewed chapter?

The answer is in the story: in 1978, Albania ended its "eternal friendship" with China, just as it had broken off relations with its Soviet "Big Brother" in 1961, and, earlier still, had broken its fundamental bond with Yugoslavia under Tito in 1948 in the aftermath of World War II. China disappeared from the Albanian horizon; as did any pride in having visited Springtime Park, or walked along the Yellow River, or certainly in having shaken the hand of the Great Helmsman. The memories have been repressed and the photographs destroyed, the vast majority at any rate.

A history of Albanian photography would doubtless never mention these trips to China, which, by the photographers' own admission, were of no benefit to them whatsoever. And, indeed, we may never have learned of them at all if not for three notable encounters and a few strokes of good luck.

It all began with a meeting in November 2009, with Fatmir Veseli, one of Refik's two sons, who today manages *Foto Studio Sporti*, the same studio reopened by his father after the fall of the communist regime, in downtown Tirana.

Refik Veseli

We had heard of Refik, renowned as much for being a great photographer and master of the portrait, as he was for his personal integrity. We knew little more than that when we went to see his son Fatmir, now the custodian of his family's history since Refik's passing in 2000. Fatmir gladly shared his father's story with us, though it quickly became clear it wasn't his first time to do so. The story Fatmir told centered around Refik's friendship with a Jewish photographer during World War II. And indeed, Refik had gained a certain notoriety in this regard: as the first Albanian to receive the honor of "Righteous Among the Nations" in 1988, he had been permitted to visit Israel in July 1990, well before the fall of the Albanian communist regime.

As we later discovered, several American publications had already written about the Veseli family and how they had hidden, and undoubtedly saved from deportation, many Jewish refugee families in Albania — Mosha Mandil's included.

The trip to China was secondary in the account given by Fatmir, mentioned only in reference to a letter sent to Mosha Mandil while abroad. Indeed, Fatmir described a correspondence between the two men that was steady and faithful despite Albania's heavy restrictions on communication with the outside world. As this photo-roman affirms, he had no pictures to show us of his father's trip to China — Refik had burned them all. But he did give us access to his father's letters from Israel.

Pleurat Sulo

When we met Pleurat, he was over seventy years old and had a small photo shop in Tirana that he would close a short time later. We were initially interested in interviewing him as one of the few professional photographers to have been imprisoned during the communist period. As it happened, he was also among those who had traveled to China with Refik Veseli and, in fact, was the leader of the delegation. Pleurat patiently explained the antiquated method of color photography (based on tri-chrome printing) in which they were trained in China, stressing the complexity of its implementation as opposed to the then readily available color film.

To our great surprise, Pleurat offered to show us pictures from the trip to China. This was of course the last thing we expected, assuming anyone involved in the delegation had completely disposed of such vestiges. But the steps involved in destroying these photographs were more complex than we'd originally thought. The photographers had

initially destroyed any images of Mao or their meeting with him following the diplomatic break with China in 1978. There were never any guidelines to this end, but the message was clear to disassociate oneself completely from enemies of the regime.

Later, in 1984, Pleurat Sulo was arrested for "pornographic propaganda" and "use of State equipment for private means." His crime was to have photographed an actress in the nude (the genre of nudes, associated with Decadence was strictly prohibited) with camera equipment from the National History Museum's photography lab. He spent a year in prison — the length of the investigation — before the charges were dropped. Nevertheless, the arrest necessitated that the other photographers of the delegation disassociate themselves from Pleurat as well. As such, fourteen years after their journey to China, they had no choice but to destroy any remaining photographs — with few exceptions. Pleurat, being in prison, was the only one not to do so. The entirety of his professional archive was burned by the authorities, but his private collection, never touched. The photographs from China were in his family album; the pictures remained intact.

Katjusha Kumi

Unlike Refik and Pleurat, Katjusha abandoned photography altogether when the regime fell (and with it her post in the government). Since that day, she has declined all requests for interviews and kept a safe distance from the public's curiosities about the dictator's private life and that of the ruling families. When we approached her through a friend in November 2009, we had heard her spoken of only in mysterious terms, as if no one knew exactly what she was doing during the years of the dictatorship. We asked Katjusha about her professional life and about her passion for photography. Surprised by our interest in her own path rather than more of the same behind-the-scenes stories about the dictator, she opened up to us. Over the course of several meetings, Katjusha provided us with much detailed insight into the photographers' work and its joys and hazards under the regime; in time, she even entrusted us with the few pictures she had saved from their trip to China.

Katjusha did indeed work in a secret laboratory for the exclusive use of Enver Hoxha and members of the party's political bureau. She developed, printed and maintained the dictator's personal photographs, continually having to erase from the prints any persons Hoxha had deemed undesirable.

Upon Hoxha's death, the military confiscated all of the lab's negatives and images in order, they said, to store them safely underground. Katjusha lost a lifetime of work.

Nevertheless, she had enjoyed a privileged position under Hoxha and had been allowed to keep a few pictures from her trip to China (ones in which neither Pleurat Sulo nor any leaders of the regime appeared). Though not a propaganda photographer herself, Katjusha was responsible for the immense collection of images from which the various propaganda institutions were permitted to draw. As a result, she had a more intimate relationship with the dictator and his collaborators, more than any other photographer. Her lab — Enver Hoxha's lab — was considered the best equipped in the country, at least in part because of Hoxha's personal interest in photography and cinema; Katjusha had access to the newest cameras and latest techniques. She was even allowed to travel to Italy in 1980 for specialized training, at a time when few photographers were permitted to leave the country and when travel to the West was reserved for the ruling elite.

Like Refik and Pleurat, Katjusha was an "institutional photographer," a position regarded universally as privileged though the working conditions and quality of equipment varied significantly according to the importance of the particular institution for which one worked. The more prominent institutional photographers had access to the leaders of the regime, even to Enver Hoxha himself, on occasions such as party conventions or when traveling. Some, like Refik Veseli and Petrit Kumi, were intimately involved in creating the official portraits of the leadership. The position of photojournalist was particularly prestigious because of the freedoms it extended (many traveled about the country on motorcycles at a time when private transport was non-existent) though such freedoms were also offset by the extraordinary censorship on the part of the regime.

Along with "institutional photographers," the regime also instated photographers "of public service." Responding to the needs of the population, these photographers provided all family, souvenir, wedding and ID photos through public studios that gradually replaced the private ateliers, like Refik Veseli's, that were systematically forced to close beginning in the 1950s. These public studios used equipment and materials exclusively from sister countries (film and processing supplies primarily came from Eastern Europe), offering only black-and-white imagery until their disappearance altogether in 1991.

When we first presented Katjusha with an early manuscript of *Eternal Friendship*, the identity of the three protagonists had been protected with pseudonyms. She insisted that we use her real name as well as those of her companions. Yes, they were the propaganda photographers of a dictatorship, but their story deserved to be known. Finally, she specified for the foreign reader, Katjusha is pronounced "Katiousha."

CREDITS

THE FAMILY VESELI COLLECTION, TIRANA

Correspondence between Gavra Mandil and Refik Veseli. Nine letters and postcards dated 1967 to 1984. Until 1981, the letters written by Gavra were in Italian. All subsequent letters are in English.

Negatives, glass plates, *Foto Studio Sporti*. Various dates between 1950 and 1957. © Refik Veseli.

KATJUSHA KUMI COLLECTION, TIRANA

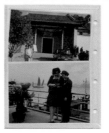

Set of 12 color and black and white photograph Various formats, mostly 4x6 inches. Taken by variou Chinese photographers. Uncredited.

PLEURAT SULO COLLECTION, TIRANA

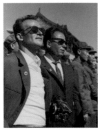 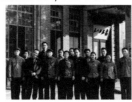

Set of nine color and twenty-five black-and-white prints. Various formats, mostly 4x6 inches. Taken by various Chinese photographers. Uncredited.

THE FAMILY VITHKUQI COLLECTION, KORÇA

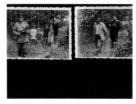

Mihal Vithkuqi was a military photographer assigned t border areas: his charge was to showcase the soldier achievements, particularly the apprehension of "dissenter (those attempting to flee Albania). © Mihal Vithkuqi.

THE FAMILY NATHANAILI COLLECTION, TIRANA

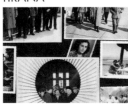

Vasil Nathanaili was ambassador to China from 1965 to 1969. His family was able to retain three albums devoted to his years spent in China, consisting of official photographs (by uncredited photographers) as well as family photos.

MOSHE MANDIL COLLECTION, UNITED STATES HOLOCAUST MEMORIAL MUSEUM, WASHINGTON, DC

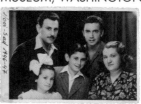

The Moshe Mandil Collection consists of 102 photograph Donated by Gavra Mandil to the Holocaust Memoric Museum in 2002. © United States Holocaust Memoric Museum, courtesy of Gavra Mandil.

NIKO XHUFKA COLLECTION, TIRANA

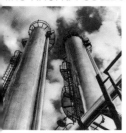

Photographs taken from *Ritmë te jetës Shqiptare (Rhythms of Albanian Life),* 1976. © Niko Xhufka.

ISMAIL STARJA COLLECTION, ELBSASAN

Ismail Starja was an "industrial production photographer." He was responsible for documenting the work being carried out in the Elbsasan smelter complex. Date unknown. © Ismail Starja.

COLLECTION IISG AND LANDSBERGER, NETHERLANDS

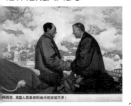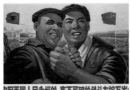

2

1. *Long live the revolutionary friendship between the comrade parties and people of China and Albania!* 21x30 inches, June 1969. Publication of the Revolutionary Committee of the School of Fine Arts for workers, peasants and soldiers. Zhejiang Province. Painters: Wang Qingsheng and Shu Chunxi.

2. *Long live the eternal and indestructible friendship between the people of China and Albania!* 30x42 inches, 1969. Stefan R. Landsberger Collection. © International Institute of Social History (Amsterdam).

THE MEETING OF MAO AND ENVER HOXHA

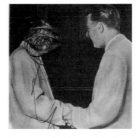

Mao and Enver Hoxha met only once, in Beijing, September 1956. Hoxha would later discuss this encounter in a chapter called "My First and Last Visit to China" in *The Khrushchevites, Memories, Institute of Marxist-Leninist Studies,* 1976. Two photographs of the meeting were published several times and in various Albanian magazines. In China, a painted version of the meeting was widely circulated, one in which Mao is demonstrably taller and Enver bows before him (see left).

Mao and Enver Hoxha, *Magazine Ylli,* 1967. Uncredited.

OFFICIAL PORTRAIT

The official painted portrait of Enver Hoxha was modeled on the above right photograph, though his chest and left shoulder have been extended in order to mirror the portait of Mao. The framing of the original, both a closer shot and with a larger border, would have framed Enver as "bigger" than Mao.

PROPAGANDA MAGAZINES AND BOOKS

YLLI MAGAZINE, TIRANA

Various photographers contributed to this magazine — both photojournalists of the Albanian Telegraphic Agency and institution-specific photographers (photographers for the army, national monuments, the ethnographic museum, etc.), including Faruk Basha, Kosta Bej, Mehmet Kallfa, Ndoc Kodheli, Niko Xhufka, Jani Ristani and Mihal Progonati. From 1964 to 1984, the only accredited photojournalist of the magazine was Petrit Kumi. He was the brother-in-law of Refik Veseli. Katjusha Kumi also had a family tie to Petrit Kumi. When Petrit Kumi left the magazine, it was Fatmir Veseli, Refik Veseli's son, who inherited the position of photojournalist for the next two years.

1964. Without credit or caption of any kind.

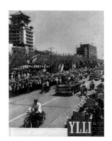

One million Beijing residents welcome the Albanian delegation. © Xinhua (Press Agency) 1966.

View of "Nanking" Boulevard, Shanghai © Petrit Kumi, 1966.

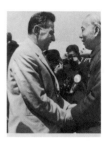

At Beijing airport, Comrade Mehmet Shehu is warmly welcomed by Comrade Liu Shao Çi. 1966, not credited

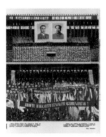

Images of the rally at the great stadium in Bejing. *More than 100,000 people cheer for the unwavering Albanian-Chinese friendship.* © Xinhua, 1966.

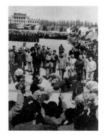

Mehmet Shehu and other members of the delegation are welcomed by representatives of the Beijing airport employees. © Xinhua, 1966.

The season of flowers. © Jani Ristani, 1963.

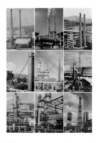
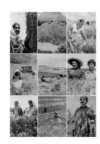
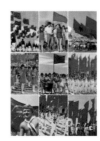
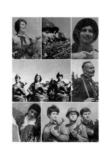
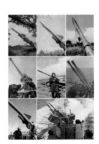

Photos taken from the magazines *Ylli, Korriku,* and *Albanie nouvelle,* and the books *Album Për gjeografinë ekonomike të shqipërisë,* Tirana, 1984 and *Bujqesia,* Tirana 1982.

TEXTS AND POSTERS

The texts on page 85 are extracted (and translated) from *Réflexions sur la Chine*, by Enver Hoxha, volume 1, 1962-1972, Editions "8 Nëntori," Tirana, 1979. *Les Réflexions sur la Chine* was published in Albanian, as well as several other languages.

"The Congratulatory Address by Comrade Kang Sheng," *Peking Review*, No. 46, November 1966, pp. 13-15. This text on page 43 is an otherwise unaltered excerpt from the original English publication.

The text by Hu Jao Pan on page 42 was translated from the French and originally published in the journal *New Albania* in 1966. The journal, a showcase of the regime, was published in many languages.

PRIVATE COLLECTION OF GOLLOSHI FAMILY, TIRANA

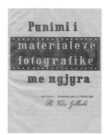

The Processing of Photographic Materials in Color, Assembly and Preparation of Equipment by Ilo Vero Golloshi. Tirana 1973. Printed by the Albanian Telegraphic Agency. 160 pages. Ilo Vero Golloshi, Albanian photographer, also received training in China for six months between 1961 and 1962. Golloshi describes two methods of photographic development for use by professional photographers.

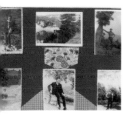

published in *Rinia i jep atdheut jetë e gjalleri*, 1979, Tirana. © Zef Shoshi.

CENTRAL ARCHIVES OF THE COMMUNIST PARTY OF ALBANIA (PPSH), TIRANA

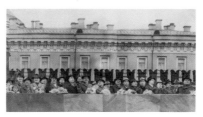

PRIVATE COLLECTIONS, PREN TOÇI

Album artwork © Pren Toçi, 1979. Translation of the poem on page 71:
Flower among flowers
embroidered
I ask nothing more

Do you recognize me?
This embroidered picture
It is a beginning
To be added to!
This inception
True embroidery

Album for the year 1957, photo no. 12, negative no. 8149. Taken from a series of albums made in 1973. Image of the grandstand for the peoples' parade in Moscow on the 40th anniversary of the October Socialist Revolution. Comrade Enver Hoxha is fifth from the left.